Bill Daniel's

# Mostly True

Microcosm Publishing

Portland, Oregon | Cleveland, Ohio

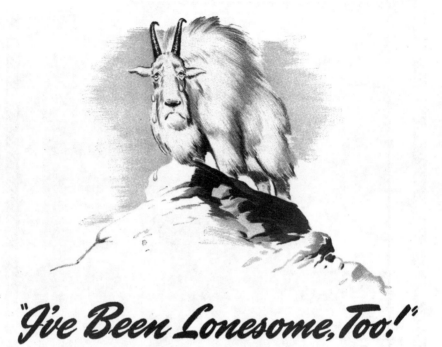

# "I've Been Lonesome, Too!"

"Summertime here in Glacier National Park used to be fun for me.

"I liked it when dudes caught sight of me and pointed. If I stood still their friends would say, 'Huh, that's only a patch of snow!'

"When city folks came climbing up these Montana mountains, I'd play hide-and-seek up high, where the clouds are born.

"I'd drink from the streams and lakes when trout fishermen looked the other way.

"But this year — like in 1943 and 1944 — folks aren't coming to Glacier Park because the hotels and chalets are closed.

"Maybe you've been lonesome for the lakes and mountains and good times in Glacier Park. Well, I've been lonesome for you, too!

"What a great day it will be when you can all come back here again after the war! The Park will be more beautiful, more inviting than ever. And Great Northern Railway will have even finer, faster trains to bring you here.

"Yes, some summer soon we'll have more fun together in Glacier National Park in Montana!"

## GREAT NORTHERN RAILWAY
### BETWEEN GREAT LAKES AND PACIFIC

*In answering advertisements it is desirable that you mention 'Mostly True'.*

2

BLACK BUTTE

· CENTER FOR ·

RAILROAD CULTURE

DOCUMENTING & PRESERVING RAILROAD CULTURE

ART & MUSIC

COMMUNITY BUILDING

HOBO BIBLIOGRAPHY & LIBRARY

MILEPOST ·345·

THE BLACK BUTTE CENTER FOR RAILROAD CULTURE IS A 501C3 REGISTERED NON-PROFIT CORPORATION PROMOTING THE PRESERVATION AND DOCUMENTATION OF RAILROAD CULTURE, ECOLOGICAL RESTORATION AND COMMUNITY-BUILDING.
800 BLACK BUTTE ROAD. WEED, CALIFORNIA 96094

# To Restless Young Men and Boys

Who Read this Book, the Author, who Has
Led for Over a Quarter of a Century the
Pitiful and Dangerous Life of a Tramp,
gives this Well-Meant Advice:

## DO NOT

Jump on Moving Trains or Street Cars, even if
only to ride to the next street crossing, be-
cause this might arouse the "Wanderlust,"
besides endangering needlessly
your life and limbs.

Wandering, once it becomes a habit, is almost
incurable, so NEVER RUN AWAY, but STAY
AT HOME, as a roving lad usually ends in becom-
ing a confirmed tramp.

There is a dark side to a tramp's life: for
every mile stolen on trains, there is one escape
from a horrible death; for each mile of beautiful
scenery and food in plenty, there are many weary
miles of hard walking with no food or even water
through mountain gorges and over parched des-
erts; for each warm summer night, there are ten
bitter-cold, long winter nights; for every kindness,
there are a score of unfriendly acts.

A tramp is constantly hounded by the minions
of the law; is shunned by all humanity, and never
knows the meaning of home and friends.

To tell the truth, the "Road" is a pitiful exist-
ence all the way through, and what is the end?

It is an even ninety-nine chances out of a
hundred that the finish will be a miserable one — an
accident, an alms-house, but surely an un-marked
pauper's grave.

BILL DANIEL'S

# MostlyTrue

February 1923
3rd Edition

$14.95

## Table of Contents

MICROCOSM PUBLISHING, 2752 N Williams Ave, Portland, OR 97227

Editor in Chief: BILL DANIEL

Art Direction & Design: GARY FOGELSON, PHIL LUBLINER, AND RICH MCISAAC

Third Edition Designers: MICHAEL TORCHIA, VLAD NAHITCHEVANSKY, JORDAN SWARTZ

Cover Illustration: MARGARET KILGALLEN

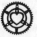 THIRD EDITION OF 5,000 COPIES · MAY 2024 · WWW.MICROCOSM.PUB

This is Microcosm No. 50 · ISBN 978-1-62106742-9

*"Gettin' by on gettin' by's my stock in trade"* –Jerry Jeff Walker

# UNDER THE EDITOR'S LAMP

## An Introduction to the Third Edition

**W**ell, the cat ate my homework. Ah, I was abducted by a UFO on the way to the office. Um, a once-in-a-century global pandemic resulted in the complete disruption of everything, including freight train graffiti journalism. . . I mean, what excuse could there be for the shameful tardiness of the new edition of this once-durable banner? Yes, we are a few weeks late with this one. 256 weeks, if you want to get picky.

And, one could fairly ask, does the world even need a 'Hobo Graffiti Magazine' at this point? Perhaps this pulp throwaway is nothing more than a cryptolectic prank. Yet, right here in these pages, there's a ton of evidence that our favorite forms of railroad folk culture are alive and well. How about the new feature showcasing our all-time favorite artist, Margaret Kilgallen? Regular *Mostly True* contributor North Bank Fred, shares his story about Cardboard, one of the last real, pre-cellphone hoboes. John Held Jr. puts the mail art practice of buZ blurr into art historical context. Whoa, the earliest known photograph of FR8 graffiti is discovered in Ohio! And, by golly, the great debate about the origins of the Bozo Texino legend rages on.

This form of 'art writing'—as Russell Butler identified it back in the early 70s—is still booming and evolving. The great rattling, rolling steel art show continues to attract and inspire new scribblers from all walks of life. We think that's a good thing, especially considering the apathy and general despair in contemporary American culture. There's still real joy in this noisy, unruly community of fugitive artists, vagabonds and researchers. Make your mark, say yes to adventure, be safe, take care of each other. See you trackside.

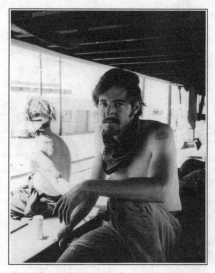

Your Editor riding the Souther Pacific Bay Area Los Angeles Forwarder in easier times

*Photo by Greta Snider*

*In answering advertisements it is desirable that you mention 'Mostly True'.*

# On *the* Spot

Letter by Hobo Jim to Editor
August 11, 1925

So far I have let you run your magazine to suit yourself—if that is the way you have been running it—and have been content that you have made a good job of it, but there is no reason why you cannot do better.

Jim Seymour

*Uh, thanks? Readers should look for Jim's astute review of Nels Anderson's book,* The Hobo *(1924 U of Chicago) in our new "Lit Up in the Jungle" book review series in the next issue.*

Mostly True,

Your publication has influenced the direction my work has gone since the day I found it at the San Francisco dump! I remember picking it up, thumbing through it and being so confused. Was it old? Was it new? I've worked in the Artist in Residence program at the San Francisco dump (Recology) for the last 13 years.

Best,
M. Gibson, Narchive
SF CA

*You discovered our publication in the solid waste stream out at Candlestick Point? That's going to have an upsetting influence on the secondary market valuation of our works. And really,*

*Gibson, an 'official' Artist in Residency program at the dump? Hell, tramps have been putting Dump Residency on their resumes since the 1850s.*

Dear Mostly True,

Maybe this is a stupid question. Is it more authentic to do your moniker with a lumber crayon or a Mean Streak?

Nick Newbie
Sheboygan, WI

*That's OK, Newbie, they're all stupid questions. I asked around the Mostly True offices and no one here knows what 'authentic' means. I guess it's just like that song, "...anything goes..."*

Dear Editor,

I am writing to point out an error in the editorial of your previous issue. This involves a character you mistakenly name "Skysail Jack London," whom you seem somehow to credit as initiating the entire phenomenon of hobo carving. Furthermore, if you had actually read Jack London's book *The Road* (which you clearly have not), you would know that Skysail and Jack London were two different people. There is little room for such errors in a field already saturated with wonton mythologizing. Mistakes of this nature should be unforgivable. I certainly hope that you will

*In answering advertisements it is desirable that you mention* '**Mostly True**'.

do better with the facts in the future.
Sincerely,
Professor Shoeshine
Inland Empire Community College

*Professor, thank you for your critical skills and bringing this embarrassing erratum to our attention. However, you should know that the Mostly True staff has indeed read Sailor Jack London's* The Road—*the mixup was simply an unfortunate typographic error, made in the haste of a demanding and relentless publishing schedule. We apologize to our readers for the inexcusable goof. The copy editor has since been dismissed. Please do keep reading.*

Dear Sirs,

What kind of a magazine is this, ANYWAY? It's been 11 years since the last issue. I would like my ENTIRE subscription REFUNDED.

Fed up,
Sam Yinzer
57 Polish Hill
Pittsburgh, Penn

*Sam, no problem. For that refund, we've credited your bar tab at Gooski's.*

I got the latest Mostly True in the mail last week, in a plain brown envelope. My mom thinks I'm getting dirty magazines. Is there something about hobo graffiti that is naughty?

T. Wayne Twax
Punkin Center, TX

*Well young Twayne, maybe we can mail out your copies inside a cover of* Boys' Life.

Dear Editor,

Lula May Perot, the mother of presidential candidate Ross Perot, was a highly spiritual woman, a pillar of the Methodist church who made sure her children were in Sunday school every week. She did not believe in spanking and rarely raised her voice, but she was a stern disciplinarian and would lecture her children to the point of torture if they got out of line.

Mrs. Perot was well known for her piety and generosity, and the hobos, when traveling through Texarkana, would chalk the curb of the Perot house with a symbol indicating an easy mark for a handout. She explained to me that these people are down on their luck. That's an important thing to tell a little child—that hobos are not scum. Her point was, their circumstances are different from ours. I think your readers might appreciate that the highly accomplished Mr. Perot grew up in such a household.

Sincerely,
Betty Lou Thelma Liz
Texarkana, Tex

*Miss Betty, indeed, imagine the independent path the country might have taken if Perot had defeated Clinton and Bush back in '92.*

To Whom it May Concern,

You like trains...? Neat... You like train monikers...? Cool... You like pretending like you know everything about both of those subjects after taking

100 pics of every sloppy graffer hand on every car of some shitty manifest from Colton...? Miss me with that shit... You either ride trains, work for the railroad or have dedicated yourself to the pursuit of marking cars and preserving the culture... Getting pretty fed up with fan boys who just bench trains but have created a moniker and bencher identity for themselves in order to trade sick packs and bottles... Or, recently common, is the misinformed fanboy who thinks they know everything about a certain moniker writer/artist and go on and on to these great lengths to demonstrate how learned they are in the game or how they know something their contemporaries don't... Ugh. Gross... You know they still make baseball cards right...? Just stick to trading those and trolling 12oz...

"Stay off the tracks. Forget it. Its a bum's world for a bum. You'll never be Emperor of the North Pole, kid. You had the juice, kid, but not the heart and they go together. You're all gas and no feel, and nobody can teach you that, not even A-No.1. So stay off the train, she'll throw you under for sure. Remember me for that. So long, kid..."

Tug Boat Captain

*What he says!*

Dear Editor,

I saw the new Union Pacific motion picture at the Majestic and it's like all railroad pictures: had many mistakes. The fireman fires an oil burning lo-comotive with wood, standing on the wrong side of the cab. Rule G was not in effect in the 60s or 70s. (1860s, or 1870s, ed.) The man who could drink the most likker during this time was considered the best railroad man. The plow point in the Jesse James picture that the James boy rings with a pistol shot was not in use until after the 90s. And speaking of railroad names, the Texas Central railroad, now part of the Katy, has always been known as the Tin Can.

I am Yours till Ft. Worth and Dallas become Siamese twins.
BOZO TEXINO

*Texino, we are as offended as you by Hollywood's gross historical sloppiness whenever they attempt a railroad movie. That's why we stick to documentaries. In this very issue we've got a swell feature about a movie we think you'll approve of. By the way, it well appears that quarrelsome Ft. Worth and Dallas are now indeed joined at the hip.*

Now that taking pictures of yourself riding the choo choo is no longer cool, I hope your publication can maintain some relevance. I only read it for the comics. You might consider including more comics in the future.

Gary Panter
Mt. Vernon, Tex

*We look forward to your submissions, Gary!*

Hey Mostly True Magazine,
I hope you will publish my poem:

Who is Texas Smash?
Known by none
Feared by all
Night by night
The ceaseless scrawl.

The Kids Are Coming
Mission Valley Textile Mill
New Braunfels, TX

*Nice piece, Kids. Now get off my lawn.*

To the Editorial Board,

So, encouraging the youth to write their names on other people's property (without permission) and steal rides on corporately-owned industrial infrastructure is your idea of wholesome enterprise? Not to mention the Intellectual Property liberties taken by your editorial and design staff... Shameful!

T. Gore
Wash. D.C.

Editor,

If you ask me, this whole deal looks like a bunch of commie fags.

Ed Anger
FLA.

Dude,

Graffiti has been dead since the 1990s. Hoboing died after the 1930s. Hobo graffiti? Gimme a break. And oh yeah, print is dead.

M. Element
Folsom St.

*This sort of stuff fills our mailbox like grocery store circulars every week. We do welcome your comments, crackpottery or not. Keep those cards and letters coming, folks!*

# Mysterious Rolling Graffiti of the Railroads

*Reggie McLeod*

Few people noticed her, despite her good looks. Larry Penn did. After that first encounter he began seeing her often—sometimes at a railroad crossing or behind a factory in East Chicago. She couldn't tell him her name or where she was from, so he gave her a nickname, Tuscan Red Rose. Through Rose he met a gaggle of characters: Bozo Texino, the cowboy with the blank stare; Herby, the sleepy Mexican; Dennis from Houston; Squirrel, who claimed to be nuts; and the distinguished J. B King.

Penn met these personalities on the sides of railroad boxcars. These quickly-drawn figures are usually dated and signed with pseudonyms, like the handles adopted by citizens band users. Some of the characters appear on thousands of boxcars and their dates span decades. Many are so common they can be spotted from coast to coast.

Penn, an aficionado of railroad lore who lives on the north side Milwaukee, began taking photos of boxcar graffiti in the early '70s. His work as a truck driver routinely took him to railroad yards where he went hunting with his camera while his truck was being loaded or unloaded. He retired from truck driving in 1985, but he still hits the road often, as a guitar-playing singer and songwriter. Besides performing in the Milwaukee area since the 1960s, Penn has been invited to play all over the country, including several gigs on Garrison Keillor's "Prairie Home Companion Show."

We see boxcars all the time without noticing these drawings, but once you spot a signature or two you begin seeing them frequently – near railroad yards or while waiting for trains at crossings. Many of the drawings are intriguing. Some graffiti are just vandalism though.

Some of the graffiti are erotic, political slogans, "fuck you"s and proclamations of love or hate. The most interesting ones are those like Tuscan Red Rose that appear on thousands of boxcars.

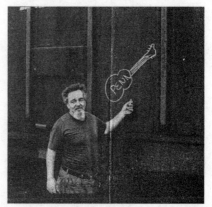

**Larry Penn** *Photo by Reggie McLeod*

Penn named Tuscan Red Rose after Tuscan red, the brownish-red paint often used on barns, boxcars and railroad buildings. Since Rose sparked his interest in boxcar graffiti Penn has been hoping to meet the artist who drew the shapely figures, but they are unsigned, adding to the mystery. Penn guesses that she may be a railroad worker.

"I'd much rather find out she was a

hobo,' admits Penn.

In 1981, Penn wrote a song titled "Tuscan Red Rose." People frequently ask him to play the song and it is on one of his albums, but so far the request in the song's chorus has not brought him any leads:

"Now a woman will do ya that way sometimes

Like a lyric way down in the prose.

She won't let you be and you'll never be free.

Can you tell me the name of that Tuscan Red Rose?"

Tuscan Red Rose *Photo by Reggie McLeod*

He hasn't given up hope.

"I asked a folklorist how to find her, and he said to put an ad in the paper," says Penn. "I thought that was a dumb thing for a folklorist to say."

So he keeps on playing the song. But who knows? Maybe late on night in a nightclub somewhere Penn will finish singing "Tuscan Red Rose," put his guitar away, sit down ad the bar and order a brandy. An auburn-haired beauty in a railroad cap sits next to him. "I hear you've been

looking for me," she says as she clicks a piece of chalk down next to Penn's glass...

Or, Penn is leaving a club after playing all night when a heap of sour-smelling rags steps out of the darkness to embrace him. The grizzled old hobo will blast him with an invisible cloud of Gallo Port breath and the revelation "Hi, I'm Rose." Penn, eyes watering, looks beyond the affectionate bum's shoulder to see Tuscan Red Roses scrawled all over his car...

Who is signing boxcars?

"Anyone with a piece of chalk or crayon in their pocket. The ones you see a lot are probably by somebody trying to see how many they can do."

Why do they do it?

"Why did cavemen write on the walls of caves? I just think it's a natural thing for people to do. I think it has its roots in man's desire to live forever."

Penn has collected stories to go along with some of the signatures.

During the depression, hoboes used boxcars to send messages. J. B. King was a hobo in the 1930s who was also a compulsive boxcar signer. He signed his name in an artful Palmer script in a single stroke, without taking the chalk off the side of the boxcar. Current J.B. King signatures are probably copies by an admirer or admirers, Penn suggests.

He compares the J. B. King signatures to the "Kilroy was here" graffiti common during WWII. There had to be many Kilroys. "I've been to places that I know no GI was there before me and I found that damn "Kilroy was here."

After playing "Tuscan Rd Rose" in Minneapolis one night someone in the audience told Penn that "Dennis from Houston" was a man who left Houston, Texas, and moved up north to put some distance between himself and some financial problems. He signed boxcars to let his friends in Texas know he was okay.

Somebody once told Penn that "Squirrel is Nuts" is signed by a Soo Line worker. Penn says he believes that because all the ones he has seen are on Soo Line cars.

Penn has documentation about one signer: A newspaper clipping tells about Herbert Mayer, a conductor in St. Louis, who confessed to drawing about 70,000 "Herbys" on boxcars from the mid-'50s until his retirement in 1981. "Herbys"—sketches of a figure wearing a sombrero dozing under a palm tree —were the most common boxcar graffiti for years and can still be spotted occasionally.

"I want to get a picture of one from every year," Penn says of the classic graffiti.

That might be possible, because Mayer is still at it. While visiting Salt Lake City a while back he signed four or five Southern Pacific boxcars. A couple years ago, while on a tour of China, he got the urge but didn't have any chalk, so he used a nail to scratch Herbys on the side of Chinese boxcars.

"I haven't lost my touch. I still do it," he confessed during a telephone interview from his home in St. Louis. Although he still knocks off an occasional Herby, in his heyday he might walk up one side and down the other of a 100-car train drawing Herbys on both sides of each car. Engineers have even stopped their

trains so he could do a quick Herby or two. He has drawn Herbys with chalk, lumber crayon, markers, and in a pinch, has dipped his finger into an oil box to paint his masterpiece on its steel canvas.

He confesses that drawing on boxcars is an addiction. In fact, he started at it about the same time he quit smoking. "I'd be jogging between cars, and when I came to a boxcar with nothing on it, I had to stop. It takes about a half a minute.

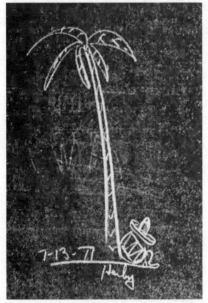

**Herby** *Photo by Reggie McLeod*

I've done it by lantern light. I do it in my sleep."

Perhaps Mayer was destined to become a boxcar artist; his father was a railroad man and his mother was a professional artist proficient in oils, watercolors and—wouldn't you know it—chalk.

It is impossible to estimate the number of cars he has signed. Thousands anyway. Some estimates have exceeded a half million.

Although Mayer's coworkers knew he was Herby, he didn't go public until he retired. Railroad workers, like firefighters, spend a lot of time waiting: waiting for repairs, waiting for another train to pass, waiting for cars to be taken off or added to a train. For Mayer, time passed more quickly when he was busy marking Herbys. His walkie talkie let him know when he was needed.

Mayer never got in trouble for his artistic compulsions, but from a distance his activities might look suspicious. Once an engineer who also worked as a deputy sheriff thought Mayer was breaking a seal on a boxcar door. The engineer took his revolver out of his lunch pail and stalked quietly up behind Mayer. He was amused to discover he had caught Herby in the act.

Drawing on boxcars is a popular diversion for railroad workers, but it is a custom among signers not to admit it. There's no way to tell, for instance, who has been signing the modern "J. B. King"s, but Mayer recalls a likely suspect. A yardmaster he worked with could copy the signature perfectly, forwards or backwards.

Mayer used to delight in conversations with unknowing railroad workers speculating on who Herby was. One of the more interesting rumors had Herbys being drawn by the ghost of a Mexican man killed in a railroad accident.

Like Larry Penn, Mayer also became infatuated with Tuscan Red Rose and tried to find out where she came from, but the mysterious lady eluded him too. "I tried to find out by hook or by crook. I'd collect

information, but nobody would admit to it. I never could find out."

Famous boxcar signatures like "Herby" and "J.B. King" may continue to be drawn by generation after generation of artist. Mayer has a copy of an article in the Oct. 1937 issue of *Railroad Magazine* explaining that

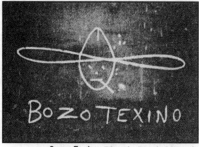

Bozo Texino *Photo by Reggie McLeod*

"Bozo Texino" is J. H. McKinley, an engineman in Laredo, Texas. The older signature included a drawing of Bozo smoking a long clay pipe and wearing a high cowboy hat with a five-point star on it. McKinley died more than 40 years ago, but Bozo lives on, through he took the star off his hat and now smokes a cigarette.

Mayer has seen many forged Herbys. One artist is signing his work "Herby II." People familiar with Herby can usually tell a genuine one from a copy. In fact, when he learned that a Southern Pacific worker was selling T-shirts, hats and belt buckles with the Herby logo on them, Mayer secured a copyright on the design and started selling T-shirts himself.

Mayer has not made the task of sorting out the genuine Herbys any easier. Although he has placed most of his Herbys under palm trees, he has also drawn the figure under tombstones, cactuses, carts and umbrellas. Mayer says he has signed thousands of different names to his

work.

Once, while attending the National Hobo convention in Britt, Iowa, he signed a friend's name to a Herby. A short time later, the man's son was waiting at a railroad crossing in Battle Creek, Mich., when he was shocked to see the drawing with his dad's name on it roll by.

Last summer Mayer tore down the old doghouse he had built in the backyard about 30 years ago. There, forgotten, on the concrete slab underneath it, was a Herby, snoozing peacefully for all those years.

(adapted from a piece in the Milwaukee Journal Magazine)

# How'd You Git That Moniker?

*"Most all railroad men have nicknames. There's a reason behind it."* —*The Rambler of Beaumont*

The Commodore *Photo by Tim Gibson*

## Story by J.Alone

I first met the man named "The Commodore" back in 2006. He was working as an Engineer on the morning switch job at West Oakland. I don't think anybody who met him or knew him will ever forget him. He was the caliber of Railroader that rarely is forged anymore, a legend from a different era, pure Southern Pacific Old Head. People like him rarely come out of Union Pacific's culture (if you can call it that). He was hilarious and witty, caustic and sarcastic, tough and grizzled, with a keen sense of radar for detecting complete and utter bullshit (of which management is adept at typing up and doling out). But most importantly he

made the job fun, he made the shanty come alive. Listening to him talk was like listening to a railroad George Carlin, although his voice was a bit more phlegm-ey and gruff (he chain-smoked).

He acquired his nickname for the incident that he was most famous for—in which two SP locomotives under his control somehow ended up in the Napa River, rolling off of the Brazos Drawbridge with all the grace of a fat kid gliding off a water slide in the 80s. Ever since that move people knew him as "The Commodore." He was given the lower-ranking designation, as opposed to "Admiral" since another Engineer had

already acquired that name due to an incident which occurred on the same bridge in the 1950s. The first guy didn't take too kindly to being referred to by his nickname, but Commodore took it all in stride, seemed to appreciate it. He would even autograph photos of the incident for other rails as payment in exchange for favors, debts, etc.

Commodore passed on last Sunday, August 19th, 2012. We've been marking his name up with chalksticks on railcars in the yard this week in memoriam of the guy we all knew who made us laugh, who made the place fun, a relic of a by-gone era of Western Railroading. They don't make 'em like that anymore.

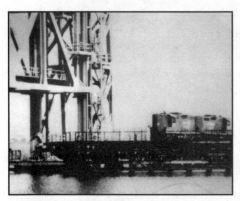 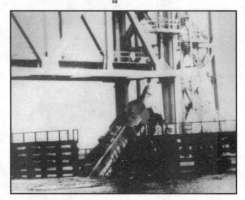

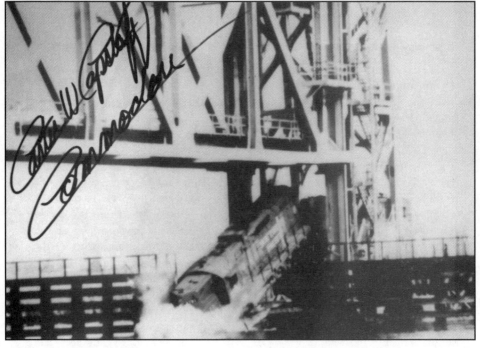

**Shellville Turn Splashdown** *Photo by Gene Poon*

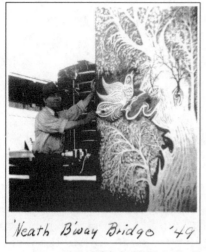

'Neath B'way Bridge '49

Tom Stefopoulos *Photo by Joan Peacock*

# The Artist of the Lovejoy Ramp

In 1948 a crossing watchman for the Spokane, Portland & Seattle Railroad in Portland Ore., named Tom Stefopoulos began painting a series of murals on freeway pillars during the slack times on his night shift. Over the next four years he produced around a dozen paintings that depict a mixture of Greek Mythology and Americana, painted in a highly calligraphic style. He initially drew them in chalk, but as passersby encouraged him, he went back over them with paint. One of the best known was of the Philosopher Diogenes, walking the streets of Athens with his lantern, looking for an honest man.

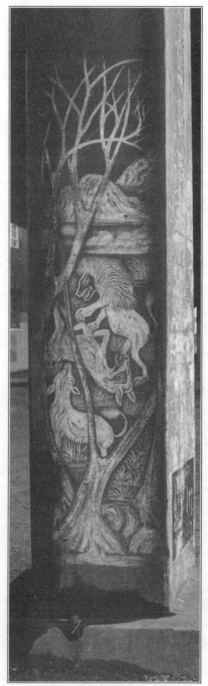

Photo by Toby Hardman

# The Secret Hobo Code

*Those Who Know Don't Tell*
*Those Who Tell Don't Know*

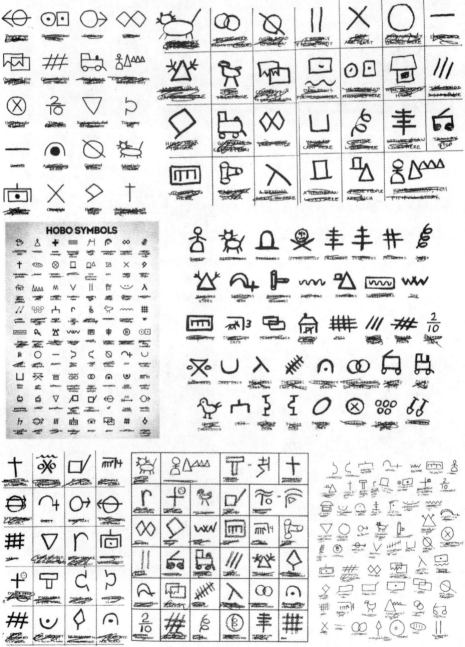

# Earliest Moniker Photograph
# (1914)

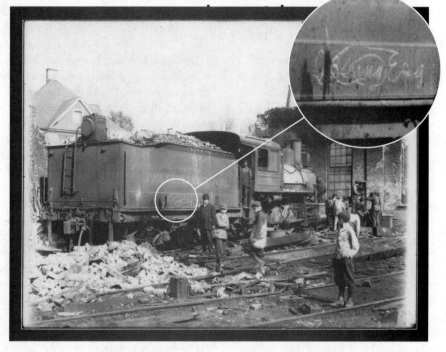

In 2018 the Massillon Museum in Massillon, Ohio, presented the exhibition, "Moniker: Identity Lost and Found." The exhibition and corresponding catalog served to document and explore a mostly arcane tradition of mark-making and monikers, grassroots movements which began in rail yards in the late nineteenth century, and continue today.

The project was born in 2014 from collaboration between three friends—Andy Dreamingwolf, Kurt Tors, and Scot Phillips. As passionate researchers of the moniker tradition, these individuals worked with the Massillon Museum to share their discoveries with a wider audience. During the project's research phase, the team's travels had them crisscrossing the country from coast to coast meeting with moniker practitioners and documenting oral histories.

While combing through archives at the Massillon Museum, a discovery was made. The mark of J.B. King, Esq. was found within an original 1914 glass plate negative of a Pennsylvania Railroad engine in the Museum's archives. King is legendary and an otherwise anonymous individual whose mark has been replicated by many to perpetuate and honor this culture. The discovery of his mark on the glass plate proved his moniker tradition was over a century old.

Not only was this a great discovery for the Museum's sake, but it became the earliest documented photograph of a moniker on a railcar known to exist. That moment solidified Massillon hosting the first

iteration of this exhibition. Ironically, while moniker art is highly visible, it is historically among the most overlooked aspects of railroad heritage. No one with whom Museum staff has spoken to date denied the significance of this unique art form, yet it is formally overlooked and, for the most part, undocumented.

The foundation of the exhibition communicated to audiences ways in which monikers, specifically, evolved since the nineteenth century to present day, and were a means of distinguishing an individual from an otherwise homogenized and marginalized group of rail workers. Historical archives, works on paper and wood, photographs and more were displayed during the exhibition. The glass plate of J.B. King's moniker was witnessed by new audiences along with A-No.1 archives and meal tickets, original Bozo Texino drawings, letters, and moniker on wood, an original Herby mark on a cut panel from a boxcar, and much more.

This exhibition also celebrated the merger of railroad history and artistic heritage by highlighting the marks of twenty-six contemporary moniker practitioners.

The primary body of work was built from relationships developed with these practitioners by the exhibit organizers. Included in the contemporary moniker practitioners were those with notable histories or influences on the tradition. Some have been marking since the late 1960s, and others have marked over 100,000 cars. What they all have in common is a love of railroad culture, and an appreciation of history. These depictions of their individual marks, along with their respective photographs and biographical information, make up a substantial part of the original exhibition catalog.

The catalog for "Moniker: Identity Lost and Found" was the first major publication undertaking a documentation of the history, practitioners, and folklore of the moniker. It assumed the same responsibility as did the exhibition: to lead viewers through the history of moniker mark-making, starting in the late 1800s, to present day.

Between the elements, buffing, and scrapping, it's important to document these marks and their stories before they and their makers are lost to time.

## FlimsiesShortReport

A new paint shop was opened in South San Francisco the first week of October. The first unit repainted was SW1500 2550 and the paint scheme is best described as "the Red Reflector". The engineer's side of the hood was completely painted in a mural motif. The S.S.F. Yardmaster intends to wye the engine so the local artists can do the fireman's side at their convenience. The paint job really stands out.

**SP Shorts** Could this be J.B. King, Esq? While in the process of setting out at West Colton, the crew of the CHSXF-09 found a deceased male on their train. It was a non-railroad related incident because apparently the deceased male was 93 years old and died of heart failure, approximately 12 hours prior to the arrival of the train at Colton...

*Reprinted from Flimsies rail fanznine, circa 1992*

# WIERD HOBO TRIP

## *Life and Times of a Tramp Sign Painter*

### *An Interview with Heidi Tullman (Part One)*

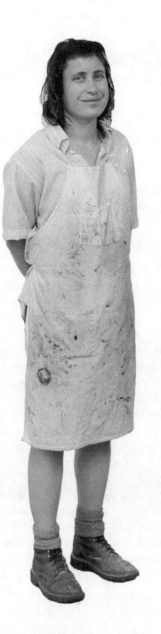

**I** am sitting out here at my usual Starbucks in Pasadena, Texas with itinerant sign painter Heidi Tullman, AKA Handsome Hand. I met Heidi at this rad experimental art school thing in Black Mountain, North Carolina in 2016. Heidi is driving her scruffy Nissan pickup filled with paint, brushes, drop cloths, and her adorable dog, Paloma, on the way from New Orleans to Siskiyou County, Northern Calif. It's a beautiful sunny warm winter day down here near the Texas coast, and so I press the record button.

**Heidi Tullman**: Sign painting got me into graffiti. I had been painting letters as signs for a couple years before I moved to New York City. I can talk shit on styles, but that's the graffiti in me.

I was living in East Williamsburg, as it was called, and was working in Manhattan, and so everyday I would see everything–starting from the Williamsburg commute and then get off the train and do the Manhattan commute. And so I saw so many hand styles. I fell in love with SURE.  S-U-R-E. He passed away a few years ago. Faust is his partner. I'm sure you know.

He does those big black letters. Giant stuff. And you know how New York is. It's just plastered. Just layers and layers of anything and everything on all of the surfaces. And so I really felt it was harmless. At the time I had access. As Kevin Caplicki says, graffiti is the most democratic thing, you know, anybody can do it.

**Mostly True**: *But it can also be a very prescribed subculture with a lot of invisible rules.*

**HT**: For sure, and it's so problematic in its own ways. Like, I could get into that, but at the time I just had big doe eyes for it. So I just picked a name and started writing it everywhere and tried to do cool handstyles.

**MT**: *Can you tell our readers what your tag was at that time?*

**HT**: NUGZ. (laughs) And by graffiti standards I am a toy. Know this.

**MT**: *So, what is your story, how is it that you were a sign painter before you did graffiti? That's the opposite of the usual path, right?*

**HT**: I moved to Philadelphia as a 21-year-old, and that was the first big city that I moved to. Urban decay, and all that. I got really into farming in Philly, like urban farming. We had a small group of people, we had this farm tour going on. We were growing all this experimental stuff in our tiny little yards. Then we decided to take a group field trip to Austin, Texas to do this radical urban sustainable training with the Rhizome Collective, who are now disbanded. So we learned all about how to homestead in the city and permaculture, and I just got real turned on by that.

So I met someone in Austin who was managing a farm in Panama. We met at a show at the anarchist book store, and he was like, "Do you want to come work on the farm? I can pay you a few hundred

dollars a month. Come down to Panama." And I was like, "Fuck America, fuck this place, I'm going there, I'm going to be a farmer, I'm going to make my way down to Panama, start my new life, say goodbye forever."

So I bought a one-way ticket, September 11, 2007, to Panama City, by myself, with like seven hundred dollars in my pocket. I had no idea. I thought I was gonna get paid. So I made my way to this little farm. I get there and the guy is like, engaged and going to Bali. But I could stay and farm. But he's not sure if the owners are going to sell the farm or not. It was just this totally flaky situation. So I had this farm to myself. And all the fruit and all of the sweet potatoes. But I didn't know anybody and I had just a small chunk of change left and I didn't have a job, and so I was like,

"Well, fuck."

So I just kind of went into town and started partying. And blowing cocaine for the first time. This was in Bocas Del Toro which is an island in an archipelago on the Caribbean side And just started hanging out and started working at Bar La Iguana. I got the idea that the bar needed some signs, so basically I just taught myself how to paint signs because I was broke.

**MT:** *And you got here because…?*

**HT:** I wanted to be a farmer. (laughs)

**MT:** *So the ideal of farming took you to first the lead paint encrusted soils of West Philly and now an archipelago in the Caribbean? Because of a visit to the crusty Texas farm called the Rhizome Collective?*

**HT:** Exactly. You know permaculture was really big down there, but it was kind of like this eco-tourism. The people who owned the land and the hostels were mostly Americans. And I kind of got in with them. I ended up moving into the hostel and staying in town. It was a two hour walk back to the farm, so I was walking from the farm to town.

So now I have about one hundred dollars to my name...

(this part of the story goes on with some unbelievable twists and turns, as Heidi starts picking

**By Appointment**

**2049 Market St. San Francisco, Calif.**

up, other sign painting jobs on the island and eventually is able to buy a ticket to New York. —Ed.)

**MT:** *So let's get back to your early Brooklyn days.*

**HT:** So I'm just trying to hustle signs. One day my friend Alison is like, "Faythe (Levine) is making this movie about sign painters, I really think you should be in it. I want to introduce you two." And I was just like, I knew I wasn't that good. Because I also had been following at that time, I think I was following only like, and this was before Instagram. So like, I had my eyes on New Bohemia Signs, Jeff Canham, Ken Davis, and not that many more people. Like, I didn't know a lot of sign painters, but I knew Margaret, I knew her stuff, and ESPO. I remember writing ESPO, back in the Flickr days, I was like, hey, "I want to be a sign painter. Do you

have any advice for me?" And really, what I wanted was just to, like, make contact with these people who I looked up to. So I remember him writing me back. And he's like, "Well, it's a long journey. Don't forget to take lots of rest and drink lots of water" and, "When you think it's over, it might not be over."

Oh, this is a perfect part of the story. I moved to New York in '09, So this is 2010 at a friend's birthday party, and this fellow Ben Wolf approaches me on the roof. I knew that he was affiliated with the Swimming Cities and that punk rafter scene. And he's like, "Hey, my name is Ben, what are you into?" I was like, "I actually work as a barista, but I'm really into sign painting. I'm a sign painter." I could say that because I had a business card. You know, "I'm a sign painter." He was the first person I told this to. And I said, "But I'm also really into graffiti right now." And he's like, "Oh, really?" and he takes his arm and puts it around me and walks to the edge of the roof. He says, "Well, my friend—I don't know if

you've heard of him—Read More Books is in town. And tonight is his last night and we're gonna go finish a spot and I think you should come." Graffiti dream date, oh my god. So that so the first time I hung out with who became my art partner for a while.

**MT:** *Tell us about your truck. How long have you had it? What's in it?*

**HT:** I got my Nissan two Decembers ago. Christmas eve, actually. And it was stolen Christmas day. In Oakland, in front of Monica's house. It was gone two weeks and then I got it back. And the insurance payout, um, it was a long story why it was even covered, but the payout ended up being my deposit for herb school, so it was this really beautiful sequence of events.

And yeah, I don't have a camper on it. I've got these plastic tubs with my clothes, my books. I have my paints with me. I have an electropounce that my father made for me. Kind of just hauling my shit around the country, 'cause I don't really know where I live, so I just take it all with me. Put a little bed in the extended cab for the dog.

But yeah, that truck has been great. I've never known freedom like this, until I had a pickup truck.

*Part 2 of this interview with Heidi Tullman continues in the next issue of Mostly True.)*

From the collection of
James Concannon

# HAND, LANTERN, & FLAG SIGNALS

by
R.J. McKAY
(CUTOFF SANTA FE BRAKEMAN)
4-1-76
4TH EDITION

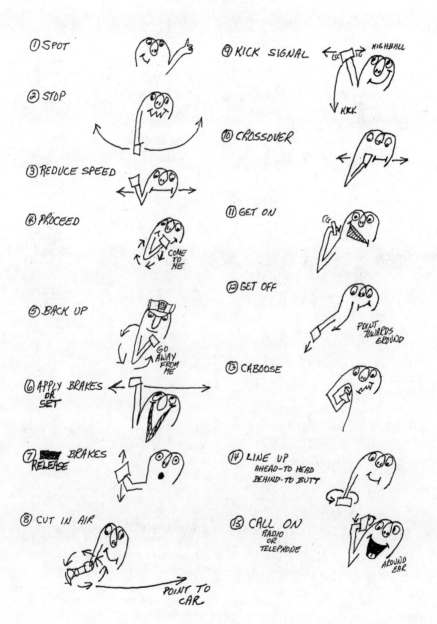

① SPOT

② STOP

③ REDUCE SPEED

④ PROCEED — COME TO ME

⑤ BACK UP — GO AWAY FROM ME

⑥ APPLY BRAKES OR SET

⑦ RELEASE BRAKES

⑧ CUT IN AIR — POINT TO CAR

⑨ KICK SIGNAL — HIGHBALL — KICK

⑩ CROSSOVER

⑪ GET ON

⑫ GET OFF — POINT TOWARDS GROUND

⑬ CABOOSE

⑭ LINE UP — AHEAD-TO HEAD — BEHIND-TO BUTT

⑮ CALL ON — RADIO OR TELEPHONE — AROUND EAR

(16) CUT CAR — BELTLINE

(17) DRAG — ACROSS CHEST

(18) DRINK-EAT

(19) ROLLOUT — ?

(20) HOUSE SIGNAL

(21) HEAD IN BACK IN — POINT TO HEAD

(22) SPUR

(23) DROP

(24) SHOVE

(25) OFFICE — ACT OF WRITING

(26) SET—RELEASE HANDBRAKE

(27) BAD ORDER RIP TRACK

(28) CROSS TRACK TO OTHER SIDE

(29) COUPLE UP

(30) JAM KNUCKLE

(31) ATTENTION — YELL LOUDLY

(32) NO UNDERSTAND

Ⓜ 4-1-76 BY R.J. McKAY

EARLY COLLOSSUS?

NATS RESIK
MOSTLY ON ATSF GRAIN CARS
STAN KISER?

SHORTY

ROLL ON ROLL ON ROLL ON

OMOR 10-2-75

THE CHAMP 12-24-79
around ST. LOUIS

OLD MAL TAMPA FLA

3-79
BRC

Thumper 10-15-79

Poncho 11-1-75

DRACO 11-26-79
McPherson Kansas

KKK

SAG 10-6-79
Porphyry CA

proxyhdo
EARLY COLLOSSUS?

KiDDER
SKIP TRAYLOR

Mainline Mac
AS DRAWN BY THE TRAVELING SWITCHMAN

35

*In answering advertisements it is desirable that you mention* '**Mostly True**'.

# TRUE TALES OF THE RAILS
## Actual Happenings Told by Eye Witnesses

### ON THE JOB

When I walked into the Y, Deanna's high-pitched cartoonish voice assaulted me, "Hey Mar-ees-uh, the trainmaster is looking for you. Hey, Mar-ees-uh, you have a hole in your pants." I look over at her conductor, some young skinny guy, has the most annoyed look on his face. It's true, her antics gets old, but she's literally a comedian on the side, so what do you expect?

My engineer for the night, Terrie Rayburg, is the woman with the most seniority in Conway. She walks in wearing carpenter style pants and a thrift store sweatshirt. She has wire glasses and plain shortish hair. No makeup and a face full of a thousand wrinkles. Didn't take long into the run to realize I'd probably gain a few myself that trip—she was the gnarliest chain-smoker I had met on the railroad. After we crew-changed, she said under her breath, "He said there was no camera. There's a camera. Guy don't know his ass from a hole in the ground."

I liked that she didn't pry into my business very much but let me jog her memory for railroader stories. One of my favorites was about how she used to sneak her little Yorkie mutt, Zeus, on the engine with her back in the Conrail days. "He was qualified on the Waynesburg". He'd sit in her

lap with his paws on the desk console and the conductors would take him for walks. I laughed, "Did the bosses know?" She said, "What bosses? This was Waynesburg. There weren't any around. I put him in my grip, and there was a little hole for him to stick his nose out."

The smell of the cigarette smoke, and her sort of rough but still-a-nice-lady demeanor reminded me of my grandma Tukie. She has this way of talking that is actually a lot like Deanna's. When she gets into telling a story, she'll go, "I says..." instead of "I said". Working for Conrail wasn't her first time working "a man's job". Terrie started working for a steel mill when she was 17. At 19 years old, they made her a foreman. I asked her if the men gave her a hard time, but she had family who worked there, so it wasn't a problem. They let her travel around to steel mills all over Pittsburgh, including the Braddock furnace. Basically, they brought her there to say, "This is our first female foreman, where's yours?" She got sick of being a foreman and started operating remote control locomotives for the mill.

When we left Conway, she had warned me, "I smoke and I run like a grandma, because I am a grandma." Terrie actually was raising her two granddaughters. During our run, she was definitely going under track

speed, even though we had the 22W, a hot intermodal mail train. When we neared Harrisburg, she slowed down even more. Her goal was to get us recrewed at CP Banks, so we didn't have to do the work in the yard. A trainmaster came on the radio, impatiently, "22, are you making track speed?" I looked at her with eyebrows, "You going to answer them?" I wasn't going to take the bullet for her on that one. But unless she's pissed, she actually talks with a sweet old lady voice on the radio. She made some innocent retort to him about making a safe speed.

She told me about all the men who chased after her at work. While she was still an LET, some Shire Oaks engineer came onto her in the engine. "You know who Weird Al is? He looked exactly like him, without the long hair." She'd find presents from him on her car all the time. Another time, a road foreman waited until they were alone in an engine and literally flexed his biceps and said, "You need a man like me." He was serious. Then there was the old bitter engineer who was known to hate women railroaders until one day, he overheard Terrie bullshitting with some other guys and turned into a softie for her. Whenever their trains passed, he'd wave his arms, and yell "Terrie!" She explained, "I attracted the weird ones. That's why I divorced twice."

Terrie asked me if I was married or had kids. I told her no. "Well, there goes your social life." She told me some stories about Richard— "Her Conductor." They met in the Johnstown yard office. They ended up

crewing together for 20 years, and she never had to worry about anything with Richard. Once, they had gotten into a big fight in the motel. When they were on the engine the next day, she lit into him, "calling him every name in the book." After some time, she got a call, "Terrie, your button's hot", meaning she had been accidentally keying the radio button so that their fight was being broadcast for everyone's eager ears. She looked at Richard, "I'll never talk to you like that at work again."

On our trip home we got an empty oil train. I thought it wouldn't be so bad, but it turned out to be another 12 hour day. We had 3 engines and a decently light train but as we neared Altoona, the dispatcher told us we'd be stopping at Antis for a helper. Terrie looked bewildered and sassed back on the radio, "We don't need a helper. I've got 3 engines." The dispatcher said, "That's what's in the computer here, let me talk to my neighbor". He came back on to say that we were going to set out 2 engines at South Fork. Now, Terrie looked really baffled. It's basically an insult to have to do unplanned work on a Harrisburg Pool train. She said, "Well, my conductor isn't qualified on South Fork, so you should have someone ready to meet us there." She looked over at me, "I don't know if you've been there or not, but I want to make it hard for them." I hadn't been there, but I had the maps and like to do the work myself. But, I knew what Terrie was going for. It's a railroader's duty to throw a wrench in when you're being asked to do more work than you expected. It's railroader duty to ensure

you're not going to be overworked without a stubborn, crotchedy, slow fight.

Once we ended our trip back at the Y, I came over to shake her hand goodnight. Another conductor walked over to us, saying, "Did she tell you she's from California?" I looked at Terrie's wide eyes and she actually stumbled over her words a bit. I was a little embarrassed. As I turned to walk away, I said quickly, "I'll tell you about it next time, Terrie!"

**By Marisa Evans**

### MASSILLON MUSEUM SHOW JUNGLE REPORT

As soon as we got to Massillon, we followed some directions that Moss had given us to a jungle they'd been clearing out under a bridge. It was a huge open patch of land between two parallel train lines. The VCU crew was already hard at work cutting back brush and setting up a fire ring for cooking. After lending a hand with the setup for a while and eyeing some passing rolling stock for familiar faces, a couple of us moved on down the line a bit to set up a secondary campsite where we could sleep when the cops inevitably busted up what was obviously going to be a massive party.

Later, we crossed town to check out the truly stunning Moniker exhibit that was opening at the Museum. I've never seen a town so small, overrun with so many dirty faces and backpacks! I swear, most of the locals must have had no idea what was happening, it seemed like there was an army of us all the sudden.

Afterwords, we made our way back to the big jungle where someone had a gargantuan pot of stew getting start-

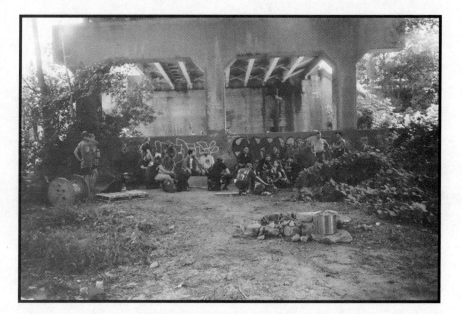

ed on the fire. There must have been a hundred of us under that bridge by the time the sun set. We drank and Virginia Zeke and others sang songs into the night. It felt like magic down there.

When a northbound junk train passed by, the whole party let loose a roaring drunken cheer. A voice in the dark then leaned over to tell us that he had a scanner and had just heard the engineer of that train call us in to the police. Taking the cue, a few handfuls of people wandered off into the misty night. Max, Bagman, and I walked down to our secondary campsite to keep an eye from a distance.

Within minutes there were police lights and crowds of people scattering into the woods. After the cops had gone, we walked back up to see what the situation was. To my astonishment, there were still two dozen hobos sitting around the fire, drinking all the abandoned alcohol, playing guitar and singing, and not only that, but the stew was ready! I asked, "Didn't the cops kick everyone out?"

"No, we told them to fuck off! We told them that we're here with Museum and they said we could stay as long as we picked up our trash."

Unbelievable, but fuck it, somebody give me a beer and a bowl, I'm hungry.

I warmed my belly on stew and my face and hands by the fire as I zoned out listening to drunken train songs. Flashlights wandered around as folks looked for their gear and forgotten beers in the dark. After an hour or so, I noticed an unwavering beam of light shining over my shoulder, as if someone had their flashlight pointed straight at my back. I turned around to see a very angry man in uniform barking "HELLO, CAN ANYBODY DOWN HERE HEAR ME???" Now this was the bull, who was apparently

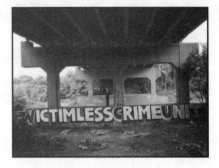

up in Cleveland when the call about us from that engineer had gone out, and it had taken him this long to get all the way down to Massillon to see for himself just what the hell was going on.

Someone yelled at him "You guys already came tonight, we're with the MUSEUM, it's FINE!" He explained to us that it was not fine, that the local police were right at that moment 30 feet above us, up on the bridge, trying to determine exactly whose property we were trespassing on. Since we were actually between two lines, it wasn't entirely clear if we were on railroad or city owned property. "I guess either way, all of you had to walk across the train tracks to get here," he pointed out.

"Not me," someon⟨ ⟩ I just jumped right ⟨ ⟩ He panned his l⟨ ⟩ 1/20 -

ing in the scene he'd stumbled into, stopping for a moment to illuminate the freshly painted "Victimless Crime Unit" piece that covered an entire wall. "I'm going to go up and confer with Massillon PD, I'll be right back... NOBODY MOVE," he ordered. The instant he was out of sight I grabbed by pack and boogied back to our campsite.

The next morning, we walked back up to the main jungle to see if anything was left. I was stunned to discover that the fire was still going and there were a dozen people still camped out under the bridge! I asked what had happened with the bull after we left.

"We told him to fuck off! We're with the Museum!"

## By I'M UGLY

### TALPA, TEXAS, 1985

During the twenty years I've been gone from the place I was raised and out roaming urban America, I've discovered a number of things that seem to separate me from the vast majority of urban Americans I've run into.

One of the most profound differences is that most of them came from growing cities or suburbs while I came from a tiny, dying town. I'm not quite forty years old and it seems to me that most everyone my age or younger comes from places defined by spreading housing development and shopping centers. My childhood was marked by decaying buildings and constant reminders of the past.

Talpa, Texas is on Highway 67 in Coleman County just at the Runnels County line. It was founded when the post office was moved considerably before the turn of the century, from a location some miles north down to the new railroad.

That was ranch country then; those were big, open-range ranches. The railroad had vested interest in changing it to farm country. The railroad had state-granted land it wanted to sell, and it wanted to sell to farmers so that a well-settled countryside might produce a multitude for the railroad to ship. The country was promoted as dryland and the farmers did indeed come. I've seen Talpa newspapers from the turn of the century full of the same sort of boomer propaganda that existed all over the west at the time. Talpa wanted to grow. But it was too dry, ultimately, to farm. As the decades passed, the farmers and their descendants left. The population shrank.

When I can first remember, the late 1940s or early 1950s, Talpa was still a viable town. Two grocery stores, a drugstore, a movie theater, as many as three cafes, a drygoods store/tailor shop, a barber shop and several gas stations fronted the block-long, unpaved main street and the highway that crossed it. A feed store was down the road and a lumberyard up behind.

But already the bank was gone—the post office where my mother was postmaster occupied the old bank building, which still said "bank" and still does today. The gin was an empty tin building, too dangerous

to play around. The depot was still there, and trains stopped for the mail. The railroad hotel was long gone, that whole block down by the railroad track marked only by a broken, weed-grown sidewalk. The old dance hall was rubble of huge rock building blocks. Rusty nails and colored broken glass lay on vacant patches, marking things already gone. I suppose 200 people must have lived there then, more for a while when an oil boom came in the early 1950s, but not many more, and it didn't last.

It was an almost perfect place to grow up. The past simmered all about me and I loved the past. My urban contemporaries had to imagine Dodge City on Gunsmoke. I had a real western town. Talpa even made the TV westerns. For some reason no one in Talpa ever knew, several episodes of Trackdown, the old Robert Culp series were set in Talpa, Texas.

Days in Talpa were quiet and slow; nights were quieter and slower. Days, old men sat on upended Coke cases at the Gulf station and watch cars pass, or they gathered in the barber shop and domino hall. The big event of each summer came in July when rodeo boosters from Coleman came to town in a caravan of cars with horns blaring. That was to gather everyone downtown to hear country music and a pitch to come to the rodeo. Every once in a while, a traveling outdoor movie would come to town and set up a screen out by the drygoods store. A few medicinelike shows came selling candy and such instead of medicine.

By the time I was 12 or so, I was

pretty well let lose to roam at night. There was little opportunity to get into trouble, except for the bombs that my friend, Robert Hale and I built and exploded to damage nothing but the silence. I exactly lived "I'm So Lonesome I Could Cry" many a summer night in Talpa except for the sound of the whippoorwill, of which we had none at least, I'd didn't know about any. Mr. Harris, who'd been the druggist since the turn of the century, kept his drugstore open late at night when he felt like it, and I'd drink soda pop there while he'd talk about things from years before. And every once in a great while, a single car would pass on the highway.

A lot more of Talpa is gone now. The post office is still open, though not in the old bank building, my mother has long since retired. A gas station on the highway sells a few groceries. I'm sure fewer than a hundred people live there now. People who grew up in Plano or Richardson haven't seen their hometown going in that direction.

But far from putting me out of step with the present and the future, I think I'm a lot more realistic and better prepared than certain of my urban contemporaries. Raised on expansion, those are now a generation of commanding expansion. They profess to believe in the inevitability (and desirability) of continued growth. Such seems to me to be impossible. This spaceship earth is finite, and we have spent its energy and resources almost to the breaking point already. With strip mining and nuclear to support our wasteful ways, we are living al-

ready close to calamity. When the breaking point comes those of us raised in silent places already gearing down, will be if anything , happier. Those raised to the sound of the bulldozers and to worship a good business climate will think the world is ending.

By Roxy Gordon

## THE SLAUGHTERHOUSE HIGHBALL

In light of the recent dialog about catching on-the-fly, I'd like to share a true story about a technique I perfected years ago in Galesburg, IL where Chicago-bounds come outta the yard too fast for a comfortable catch.

I had just jumped bail so I couldn't risk going into the yard and getting pinched by the bull. For thirty-six frustrating hours I waited on the commuter platform watching good rides fly by at uncatchable speeds until I was struck by an epiphany. With my big idea in mind, I went to the back door of the local slaughter house and bummed the butcher for a bucket of used cow belly magnets. If you haven't seem 'em before, they're

high-powered, pill-shaped, metallic magnets that farmers drop down the throats of young calves whereby they lodge in the first stomach and prevent random bits of baling wire and nails from passing through the other stomachs. Every slaughterhouse has buckets of 'em retrieved from their butchering that they keep around for farmers who wanna recycle 'em.

Anyways, I jammed multiple handfuls of these magnets in the front pockets of my camo pants, all six pockets of my army field jacket and filled my tube socks to the brim, cinching 'em off at the top with duct tape. I emptied the rest of 'em in my backpack and trudged back to the commuter platform. When the next BN mixed freight came highballing outta the yard I ran and leapt off the platform with all my might, hitting the side of that Railbox car spread-eagle, sticking to it like an octopus all the way to Chicago.

Aside from the difficulties of boiling ramen noodles and lighting cigars in this awkward position, the only other drawback was that by the time I hit Clyde yard, my backside was covered in graffiti.

By **JACK FLASH**

RAIL STRIKE '22

I have a habit of narrating my daydreams. Bad news is poetic, good news without conflict has no weight. Understanding the 2022 National Railroad Strike that wasn't is two-

*Continued on page 173*

# Preamble

## of the Industrial Workers of the World

The working class and the employing class have nothing in common. There can be no peace so long as hunger and want are found among millions of working people and the few, who make up the employing class, have all the good things of life.

Between these two classes a struggle must go on until the workers of the world organize as a class, take possession of the earth and the machinery of production, and abolish the wage system.

We find that the centering of the management of industries into fewer and fewer hands makes the trade unions unable to cope with the ever growing power of the employing class. The trade unions foster a state of affairs which allows one set of workers to be pitted against another set of workers in the same industry, thereby helping defeat one another in wage wars. Moreover, the trade unions aid the employing class to mislead the workers into the belief that the working class have interests in common with their employers.

These conditions can be changed and the interest of the working class upheld only by an organization formed in such a way that all its members in any one industry, or in all industries if necessary, cease work whenever a strike or lockout is on in any department thereof, thus making an injury to one an injury to all.

Instead of the conservative motto, "A fair day's wage for a fair day's work," we must inscribe on our banner the revolutionary watchword, "Abolition of the wage system."

It is the historic mission of the working class to do away with capitalism. The army of production must be organized, not only for the every-day struggle with capitalists, but also to carry on production when capitalism shall have been overthrown. By organizing industrially we are forming the structure of the new society within the shell of the old.

# Freight Hopping to the Wobblie Convention '89

*Ted Dement*

If I could get to Edmonton by August 13th, I should be able to hook-up with the Grievous Angels. The Angels were playing at the Edmonton Folk Festival, and would be returning east in their rented Winnebago. My hope was to be driven to Sault Ste. Marie, where I could drop south to Chicago's Wobbly convention.

Since I was in Vancouver on the evening of the 10th, with 1000 kilometers and the Canadian Rockies, between me and my goal, I didn't have much time for error. Thanks to the generosity of Eastside Datagraphics, I had 75 bucks in my otherwise empty pockets as payment for services rendered. This allowed me to buy some cans of lentils, green beans, sardines, a compass, and new batteries for my flashlight. I bummed a map off Fellow Worker Calvin Woida, who has housed me since he found me asleep in the brightly playhouse outside his door. FW Bill Culp, as a former railway worker, was able to tell me which rail yard follows the northen route to Edmonton, instead of east to Calgary.

I packed all my belongings into one backpack, and drove out into the darkened yard with Calvin. After the car drove away, I began walking along the chain-link fence, topped with barbed wire. I passed several well-lighted openings in various gates, but preferred to trespass in a darker area. Once I was in the yard, I walked towards the boxcars in the distance.

Intense yard lights caused depth perception to go out of whack, with the world transformed into islands of reflected light in a slew of solid black. I walked confidently across an open area, as someone who worked here might, and climbed on the side ladder of a car, swinging to the catwalk between the cars only when my grip was secure. In the Toronto yards, I had learned how the calm night can be shattered in a sudden crashing jolt, when the force of another car hitting the couplings ripples down from a hundred cars ahead.

I pass through three trains like this, taking a look at the manifestos taped or stapled to the sides of cars. These tell you where they are coming from, going to, and what's inside them. I make sure to replace them. Not finding a train going my way, I peer out on the other side of the three trains. There is a dirt road, a ditch, another road, and then a long line of bulk loaders that are clearly marked as grain cars.

I make my way to the jungle, where I hunker down to watch and listen. Far up the road, I can see a truck coming. It appears to be stopping at each car and, as it come closer, the hiss of steam can be heard when ever it stops. This is good, I think; if a brakeman is checking the pressure lines, odds are good that the cars are rolling out soon.

I decide to not approach the man in the truck; the crackling radio he is constantly talking into unnerves me.

When he is passed, I walk across the train and hop onboard and then over the other side. I look for manifests, but find none. I don't know what this means, but I suspect it means they are empty and going back. Being Canadian wheat cars, I'm almost sure they are going in my direction.

Suddenly, the air is filled with a creaking crash as several engines are slammed into the front of the cars. Slowly the cars are pulled forward. I am frozen with indecision. I have no guarantee this train won't cut east towards Calgary. It is moving faster now, I don't have much time to decide. I grab a passing rung and swing up. Sticking my flashlight into the service hole at the front of the car, I see it is covered with oil. I jump off, almost falling, and begin running beside the rumbling giant. The car passes me and I am able to swing onto the car behind. No turning back now, this thing is going too fast and yard buildings are coming up on my left. I dive inside the access hole, frantically pulling my backpack with me.

I can see a cluster of people pass outside. I feel the floor, and am rewarded with the feel of dry dust, as opposed to oil.

Before long, I see that the track has narrowed to one or two lines; we are out of the yard. I turn on my light and inspect my surroundings. Outside, there is a metal "porch" that is as wide as the car and extends out four feet ahead. I am inside a two and a half foot hole with similar holes to the left and right emptying into small compartments with not quite enough space to lay down straight. The walls were fire engine red, and fine dust covered everything.

I crawled out and stood against the railing, wind in my face, as we rushed alongside the Fraser River. After spending a few hours watching the scenery and singing myself hoarse on Joe Hill's song, "Where the Fraser River Flows," I unrolled my sleeping bag, stuffed toilet paper in my ears to lessen the pounding of the wheels beneath me, and fell into a cramped sleep.

I awoke at dawn to chill mountain air. As the sun filled the sky somewhere unseen in the east, the shapes of the Canadian Rockies rose up around me. Wind whipping at me as we travelled high passes above rivered valleys, I thought that if I had to die, this is how I'd like to go.

Vivid images run past my eyes now, of plunging into the damp blackness of a mountain, and then exploding back into daylight as we shoot out onto a fragile bridge 500 feet above the green and white fury of some nameless river. Tens of thousands of nests bored into the sandy cliff-face by a century of birds, a black bear running beside the track, the mineral-rich lakes of opulent blues and greens, white capped majesty reaching up to blot out the sky, and the clean-cut forests shaved off the face of the earth.

Shortly after midnight, I awoke to the final crashes of a stopped train. Outside is a yard, which I figure is Jasper. I got back to sleep, but by dawn, we haven't moved. I get out and inspect the yard. After five hours of watching the trains, and dodging railway police, I have figured out that there are two trains, including mine, that are being "made up" with additional cars, plus one or two others

on the other side of a wide dirt road. Finally, at 11 am, a line of grain cars moves out on the other side of the road. I make a dash across the open and swing on board.

It was in the Jasper yard that I came across evidence that hopping trains was still a widespread means of transpo. I remember looking into one access hole and seeing a neatly folded map sitting next to a pack of cigarettes, two other holes had old manifests scattered about inside, and the hole I rode out of Jasper in had wooden boards to insulate you from the cold metal floor.

As we left the mountains, I was startled when I looked up the car ahead and saw another person's head sticking out from the car directly before mine. An hour later we pulled over to a side track to let another train pass by, and an old guy got up out of the jungles at the side of the track and ambled over to the tracks, disappearing into a car near the caboose!

As it turned out, I was able to meet my friends in Edmonton and drive across Canada until I dropped south to Chicago. But, that trip has really sold me on the use of freight trains for long-distance travel. I strongly recommend its use to any Wobblies wishing to break free of the drudgery if hitching, and the expense of commercial travel. More visiting and hospitality between union members would no doubt bolster the forces of solidarity in this union, much as the web or relations did in the earlier, more transient, days of the Industrial Workers of the World. 

# Whole Earth Hobo

*Dan Leen (author of The Freight Hopper's Guide to
North America), the first Hippie Hobo?*

*Text of Dan's from the 1971 edition of
the Last Whole Earth Catalogue:*

You do OK by hitchhiking but hardly a mention of freight hopping. In the U.S.A. this is technically illegal, but in many areas, particularly in the west, it is allowed in order to have cheap labor available for the big farmers. For example, you can catch a ride from Seattle's Interbay to Minneapolis or on to Chicago in 2 or 3 days respectively. Also from Chi-town (if you're very careful in the yards) and Minneapolis you can go down to St. Louis or Kansas City and thence to L.A. via the southwest and thence up the coast to Seattle again. There's spots where you have to be cool and awake to avoid getting kicked off a train, but you soon learn where and when. One sees a part of America few people see anymore, too. Some roads (like the U.P. and a lot of southern and eastern lines) won't let you ride, but then again, this is always a relative thing, depending who knows you're on a train, and who you ask. I advise caution to keep from an avoidable 30 days in the city jail and also to avoid getting cut in half or wiped out by a switch standard (if you are gonna mess with a train when it's moving, you better know what you're doin', otherwise stay on or stay off till it stops.) You can get up to Prince George & Prince Rupert, and east and south as you find possible, I've heard good & bad things about Dixie and Mexico (RE: freights) and don't know. Information is half of your ticket—ask the workers (particularly the switchmen in big years) when and where a long shot is being made up for your destination. Be cool with RR dicks, they exist but sometimes you can meet them in spite of intentions otherwise. "Innocence" is helpful in such cases; tell 'em you didn't know you were doing anything wrong and don't want to...etc. I find empties (opened boxcars) the best, except in very good, warm weather. Sometimes you might even get a ride in the caboose ("crummy" its called) for a division or two. There are lots of things that are "dangerous" like shifting loads crushing people, etc., that I can't ever completely cover. Sensitivity and awareness about how the train functions is the other half of your ticket. Bring your own food, water and warmth. I guess there's a lot to it, but no more than a lot of things. Well, as they say at Suwa-no-se Jima, Sayonara, you all! Keep on truckin'.

Shanti to Alan who was able to write a personal letter about a gristmill we ordered.

Hope to see you all,
Daniel G. Leen

# Salon Style

*le fier fessier de l'avant-garde*

*Mari Cutpiles*

*L. Fong*

*Mojave Witch*

*Heidi Tullman*

**Smokin Joe** *by Larry Penn*

*Russell Butler*

Other

Russell Butler

West Coast Blackie

Aaron Frisby

Old Broads

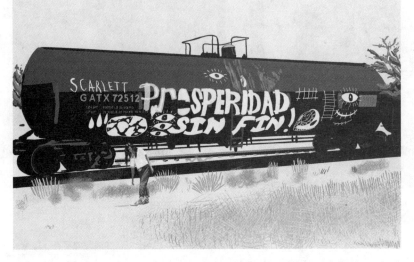

Tanker by Amanda Wong *by Anson Cyr*

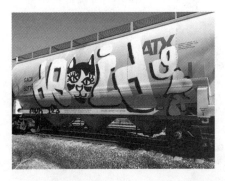

*Droid*

The Sleeper

*Tim Conlon*

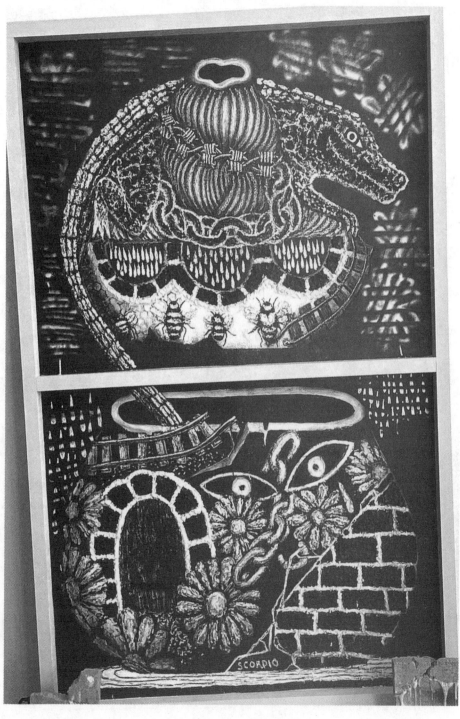

*Anson Cyr*

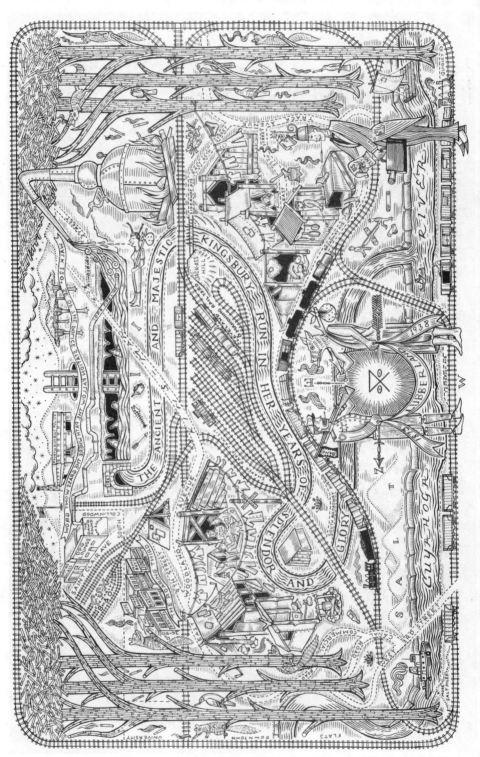

*Map of the Kingsbury Run in her Years of Splendor and Glory, 2010 By Duke Riley*

54

55

# HERBY

"Herby" secret is out

Tracking the doodler: Action Line identifies artist of rails' 'Herby'

Columnist launches search for railroad artist 'Herby'

Railroading's 'Herby' goes international

Local railroader uncovers the REAL Herby

## Smile—Herby Loves You!

St. Louisan Draws Attention To Boxcars

The face behind Herby finally is unmasked

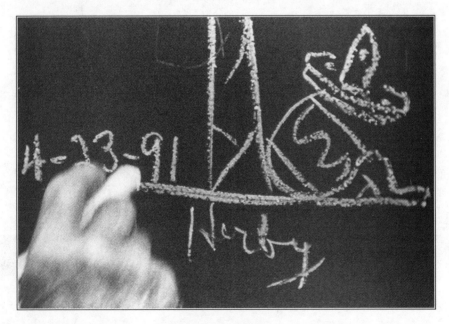

# Herby

*Yo Soy un Hombre Sincero
de Donde Crece la Palma*

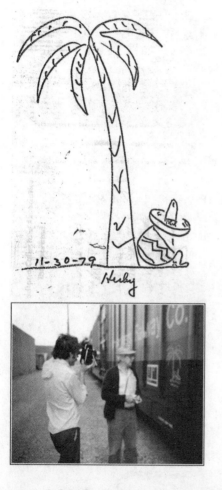

11-30-79

Herby

**On a freight trip** down south back in '91 I decided I'd beat it home to the west coast the easy way—I got a drive-away car. On the way back from Texas I figured I would stop in St Louis and try to visit the legendary Herby. A couple months earlier I had learned that the classic sleeping Mexican was drawn by a Mr. Herbert Meyer, a then-retired railroad employee in St. Louis. The drive-away car had to be delivered to its owner in Seattle in a few days, so me and my partner, Mudflap, after a visit to buZ blurr in Arkansas, had only one brief afternoon to spend with Mr. Palm Tree Herby. I managed to shoot about 3 rolls of sound super-8 film, a hundred-footer of 16mm plus-x reversal, and I recorded about a half hour of audio on a cassette. Herbert turned out to be a sweet, soft-spoken gentleman. I felt lucky to get anything on film that day and the shoot ended when the last 2 1/2-minute roll of sound film tailed out right in the middle of his story about seeing the "original" Bozo Texino. I had no idea who he was referring to at the time. It was a couple years later when I found out about J. H. McKinley, that I realized that Herbert had actually seen drawings by Mr. Mac in the 1930s.

*-PhotoBill*

57

*Who is Herby?*

Herby is a separate person from me. I can't say he's alive, but I do say that he's not me. He's Herby, and that's the way my family is; we talk about Herby and that's the guy under the tree. I will say for your information that he's always on the right-hand side of the tree. You won't find him on the left-hand side. I have seen some that would draw that. We had a fireman on the job that said, "I don't know why you always have him sitting in the sun." He figured the sun was straight up. I tried to tell him the sun was behind him, and he actually was in the shade.

*Tell me about the first time you did it.*

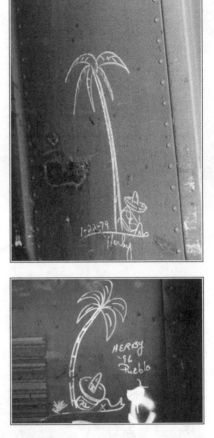

Oh my! You're talking, about how many years ago is 1957? [reading a newspaper clipping] It says a Special Agent in Sparks, Nevada said that "Herby is the name of a carman who worked for the repair facility in Roseville, California. Herby had a reputation of not liking Mexicans, so some of his fellow carmen started drawing pictures of a Mexican on boxcars and signing it Herby, and the real Herby went nuts." I don't

"Oh, That's a Load of Mexican Jumping Beans"

know anything about that. Here's one, [reading] "The Mysterious Art-ist Who Has Drawn Some 60,000 Herbys On The Sides Of Railroad Boxcars For The Last 25 Years Has Finally Identified Himself."

When I got out of high school I got a job, I graduated in 1936 and got a job on the transfer track, which wasn't the railroad itself, but we worked on railroad cars. And I used to see hundreds of Bozo Texinos written on the old wooden boxcars. He was supposed to be the yardmaster on the Texas and Pacific.

I had an industrial job. We were switching American Zinc, Mon-santo, and a few other industries. And somehow or another at this zinc plant, the clerk who would come out to tell us what to do with the cars wouldn't be there. He always managed to lay back. So we're standing around talk-ing and smoking and this one guy I'm working with, he had a drawing. He would chalk the cars "weight this one", "this goes 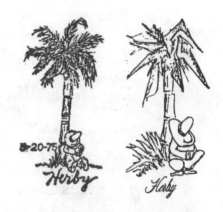 to town" and whatever they were, you know. Well, he got to doing his doodling there. I don't know how come, maybe this is where this Herby thing started.

Now I smoked up a storm. I used to carry pipe tobacco, cleaners, ream-ers, cigarettes, matches, lighters, and all that stuff. And that was 1957. And I quit smoking then, and I took up this drawing. When we were standing around waiting for the Yard Clerk to give us our information, why instead of lighting up a cigarette, I'd just go around and draw my Herby.

*Where did the image come from?*

Where did my drawing come from? Well you've seen drawings or car-toons of that, of a Mexican peon under an adobe hacienda. You know they don't like that. The Mexican people thought it was an insult. And it isn't really; I mean it's a siesta thing that Mexican people, Spanish people, a lot of countries do that. In fact one of the books I'm telling you about mentions it. It's got a whole chapter about the siesta and we all should rest up.

I had a lot of people say "Why don't you do a different one every time?" If I drew a different one each time do you think you would have noticed it? Naw. The fact of every car you saw, that's what you noticed. You talk about them being all the same. I've done 'em leaning against a tombstone, one wheel cart, holy cross, telephone poles, Christmas trees, you name it, I did it, see.

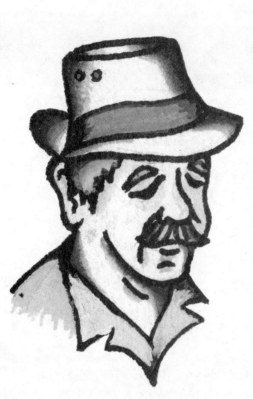

Herbert Meyer *by Kyle Cochran*

We had a taxi cab driver, our railroad would haul us around in taxi cabs (laughs) and he would say, "I don't know if you're getting behind with your hauling, but I saw a hundred-car train go by and there were only two Herbys on there." I would say, "I had most of them on the other side."

This clerk I worked with, he and his wife were stopped at a crossing, and a Herby goes by and he says, "I work with that guy" And she says, "That makes that those marks? What's wrong with him?"

I had a conductor on a Burlington Northern, he was on a block coal train, and they had 60 or 70 brand new cars, open hopper cars, and I was going down that (drawing Herbys.) He came down there, oh man, he raised cain about it, "... messing up them new cars..." I says, "Any of 'em belong to you?" He just kept going. I used to get a little guff once in a while. I've had railroad police come up on me and wanted to know what I was doing, and they say, "Oh, you're Herby." and leave me alone. It looks like I might be breaking a seal at a distance, you know, that's another story. Anyway, Cotton Belt trains would pile up on the mainline, the yard would be plugged, and it's a 4 track mainline, I would just go wild. You know it's like a drug to me. I would just go up and down both sides. Then we went on into the Cotton Belt yard and went to lunch in the carman's service building and I overheard a carman

say, "You all say Herby is here in St. Louis," he says, "He couldn't be because that train just came in from Pine Bluff and he's on every car!"

They figured I drew 700,000. Now you know that couldn't be. Many times the carmen would be making up a train for us and I would go around a hundred twenty five, thirty cars. Now that's double, both sides. But I didn't do it on tank cars, or dirty old boxcars. It had to be where it could be seen. One time I was walking around a train and I heard somebody talking. But I couldn't see anybody around. I looked on both sides and underneath. One of the carmen had dropped his walkie-talkie and it was talking under the boxcar. Another time I was drawing on this boxcar and two men jumped through the train, one on each side, and came up to me. Well, they were terminal police. I said, "Hi guys." "Hi Herby." they said. I said, "What are you looking for?" They said, "That's a car of whisky we're watching" I said, "I wouldn't be picking on that."

Cesar, who wrote for the Trainman News, our union paper, requested that Herby, or anybody who knew Herby contact him. He had five different people come and say they were Herby. But he said, "One stroke of the pen, I knew they weren't."

*(Next, I ask Herbert about the local yards)*

Why do you want to look up a railroad yard?

*I'd like to get a shot of you doing a Herby.*

Well, I don't know. They tell me I'm not an employee anymore. Even the train masters and the fellas I used to work with on the railroad. A couple of years ago I went over to Madison yard, and the trainmaster, I remember I broke him in when he was switching, I said, "Jerry, I'd like to have permission to go down to 82." He says, "What do you want to do?" "Well you know what I want to do." "Ah, you can't do that," he says. "Not anymore." He says, "You're not allowed in that yard." In fact, I was told that they wouldn't even let a non-employee into the parking lot. I tell you, if I would try to do today what I did... all this stuff. I had an engineer stop a big train and point over there and say, "Look over there, there's five white Soo Line boxcars." I'd hop off and run over there with my black crayon and... Now, today, I'd never get away with anything like that. And he wouldn't either. It seems like everything is so much more controlled these days. Oh Yeah. You can tell by the strike we tried. Our union tried to strike. It didn't last long.

# PHOTOGRAPHIC DIGEST

*Formerly SHUTTERBUGGERY*

California *by Nico Turchetti*

Amelia, Southbound out of Dunsmuir *by Beau Patrick Coulon*

Jax, Northbound, Central Valley *by Beau Patrick Coulon*

Untitled *by North Bank Fred*

Self Portrait *by North Bank Fred*

Will Davis, 1992-2021 *by Sam Liebert*

Between N. Laredo and Mexico City, 1986 *by Scott Van Horn*

Waiting for the Train, NWP, 1988 *by Toby Hardman*

KCS No. 2021 West Bound at McNeill Crossing, Shreveport, LA 2000 *by Conway Link*

Cigarette Cab *by Brice Douglas*

Untitled *by Marisa Evans*

Untitled *by Anson Cyr*

Tex KT *by Charles Wray*

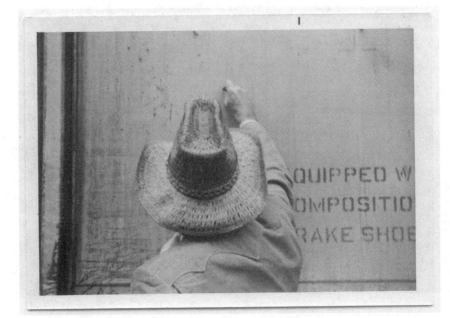

**Russel Buttler in Action** *by Tav Falco*

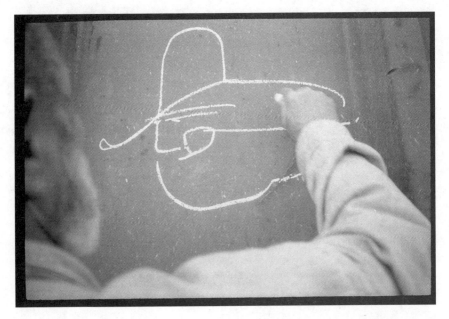

**Colossus of Roads in Action** *by Photobill*

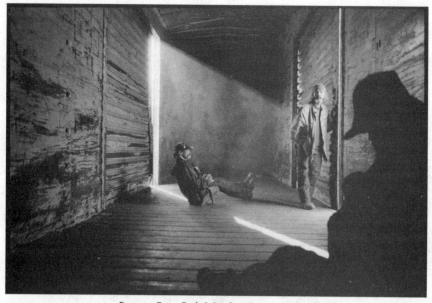

Dogman Tony, Tuck & Patches, Boxcar, Nebraska '01 *by David Eberhardt*

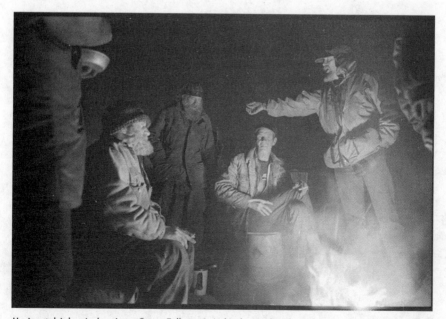

Horizontal John, Joshua Long Gone, Tallman & Ardvark, Jungle, Klamath Falls, Oregon '97 *by David Eberhardt*

Bukworm, Cleveland *by Habanero*

Glenwood *by Xtos Pathiakis*

Winston Link & George Thom with night flash equipment *by O. Winston Link*
*(Courtesy O. Winston Link Museum & Winston Conway Link)*

*An excerpt from*

# Graffiti On Low or No Dollars

*a new book by Elberto Muller*

## MINNESOTA
*She knew every word of the city, carved in concrete*

South St. Paul (UP) Downtown is a ghost town, a cardboard movie set. In the afternoon, the actors go home and the place empties out and the facades become real. Old men stroke their long white beards in the parks on summer days, stretched out reading newspapers, the houses are cardboard cutouts and Hmong women sell bright red radishes and glowing bouquets of kale at the farmers market tucked between sandwich shops and old diners. South of downtown, the trainyard with a daily northbound freight to Duluth. Henry, Nan and I sit in the steep hillside brush for an afternoon, eating burritos and spotting for a ride out of town.

The freight train pulls in the late afternoon, sometimes backs into the yard to pick up another string of cars, before launching forward across the bridge and onwards to heaven. Flanders, the electronic freak from Kansas, has called and found out where we're waiting—he climbs down the ivy covered hillside, looking like a skinny mad scientist in his wire framed round glasses—we draw pictures on the train cars, and suddenly the air brakes go—the train is already moving—we hop on, hide inside the cubby holes of the potash cars, headed for an interchange with Canadian National outside Superior.

For the first time and possibly the last time, I get to ride across the railroad lift bridge over the Mississippi in St. Paul, the one with the little house above it, the house I used to look at every day when I worked in an office in St. Paul, thinking about suicide, trying to save up enough money to escape the Midwest. Every day on my lunch break, rain or snow or humid summer sweat, I'd leave my cubicle, walk across the bridge over to the island, and look into that little house, wondering if there was a family who lived there—a little porch out front, with a potted plant that came alive every spring, a little porch that got shoveled in winter, as if the house sat along a city street and not on a cement platform one hundred feet above the river, a little house that lit up at night, with a kitchen inside, rising and falling with the passing of barges forever, freight trains rumbling below.

We crossed the bridge, our train veered left at the triangle, signaling Superior Wisconsin instead of Fond Du Lac. I texted Alex Pig and told him we'd be going by his area in northeast Minneapolis in half an hour—he went out to the tracks, watched our train come by, I snuck out and waved at him as we passed—a short ride. A few hours up to Superior, the yard a few miles outside of town, we hopped off an' had a long walk, then a short taxi ride, slept well, got confused as to what the hell we were doing in Superior Wisconsin and came right back to Minneapolis...

## WYOMING
*Make believe we live again*

Highballing on Union Pacific across the high desert, tangerine sunset criss-crossed with electric orange chemtrails and the washed-out fizzle of high cirrus. Hopped on a short Z train that blew right through the last crew change, 70 mph, this must be the hotshot to Denver.

Fuzzy mist settles mold-like onto the gray-green valley with purple mountains hovering above. Antelope, snow fences, not a tree in sight but for an occasional solitary scrub pine marking the driveway to a red one-story ranch house up here in the empty realm. The crisis of beauty, slipping away like a snake down a hole, the sun extinguished beyond the farthest hills, hissing in pink as the freight pulses forward into the icy night...

## CALIFORNIA
*One knife, brightly sharpened*

West Oakland (BNSF) Cheeto lives here in a little house on Wood Street. Big Bill used to live a few blocks down underneath a skate ramp in Jery's backyard, and now he's dead. Died up in Arcata in the back of a van on New Year's Eve. Papa lived here somewhere, too, covered in tattoos from throat to foot. He robbed a few people and got a bad reputation so he left Oakland to back to Chicago, Dallas, New York. Papa's dead now, too, they found him unconscious in the tarpaper shack next to Newton Creek, the Superfund site in the Maspeth area of Brooklyn—he'd been living in that shack for a few months, the week before he died someone came in and robbed him at gunpoint—robbed him of all his stolen ski jackets—those jackets a sort of currency among certain sects of the population, boosters or rackers they call themselves, people that walk around wearing gold necklaces with little keys on them, not keys but tools you can use to remove the security devices from items of clothing— not necessarily my kind of people, but they exist and I cross paths with them not infrequently— Papa took some big shot of dope, it must have been huge—I once saw him do four bags in a shot and it couldn't knock him out— took this big shot after bringing his generator in from outside the

shack, nodded out on dope, then let the carbon monoxide take care of the rest (thoughts in the sky increasing as the body dies)—

There's a picture of them together—Big Bill, Papa, and Cheeto—taken somewhere in Oakland maybe four years ago—three people who don't have sterling reputations, maybe a lot of people loved Big Bill, I know I did, and Papa was love-him-or-hate-him type of guy, and little, long stringy blonde Cheeto—pyromaniac freak from the Pacific Northwest, trapped in a grimy house on Wood Street, frantically pumping naloxone into all the guests from the East Coast who roll through to overdose on West Oakland dope or Fillmore fentanyl—well, all I'm saying is that of the three people in that photo, now two of them are ghosts, and I think about Cheeto out there with no phone, no money, soot smeared on his face from a sheet of aluminum foil he uses to smoke his drugs, little freebaser angel, one of that tribe called the Foil Smokers, leering out from beneath the flaps of dusty tents in Oakland, in Stockton, on Skid Row in LA, cleaning the soul with liquid silver smoke, pink-rimmed eyes growing grayer with every puff, and I think of him and the Desert Yard rats, living in hundreds of shacks that have gradually filled in the area under the freeway overpass while Union Pacific trains thunder through, shacks that sit between piles of overturned automobiles and gutted air conditioners, stripped by meth addicts like the carcasses of wildebeest by vultures, but for copper or carburetors or catalytic converters instead of flesh, the scrapper's fat and gristle, or in Mosswood Park, people crowded in tents, having guns pulled on them for a half pipe worth of crystal or tar heroin and the change in their pockets—just the idea of having a gun pulled on you in a tent, and the regularity of this occurrence—I think Oakland is just a pretty weird place to catch a freight train out of, and San Francisco is just a dead end ruined-by-tech capital, and the rest of the bay with its reputation for strip malls, yuppies in camping gear and weather so perfect it seems pumped-in— well, I guess you just have to go see it for yourself.

# Road Hog U.S.A.

*From Crown Prince to a King*

"THE DRIFTER"
"500 JOBS AND 500 JAILS,"
"A DRIFTER OF HEART, MIND, & SOUL,"
"THE RAILROAD IS HOW I SET SAIL,"
"GOT 3 HOTS & A COT, NO FAIL,"
"ROAD HOG" IS ON THE RAIL TONIGHT,"
"GO TOMORROW, TO SEE THE LIGHT."

WRITTEN BY,
"ROAD HOG" U.S.A.

"NATIONAL KING OF THE HOBOES" 92-93
BORN NOV. 26, 1940, CAUGHT THE "WESTBOUND"?
"RODE THE RAILS 1957 TO 1994"

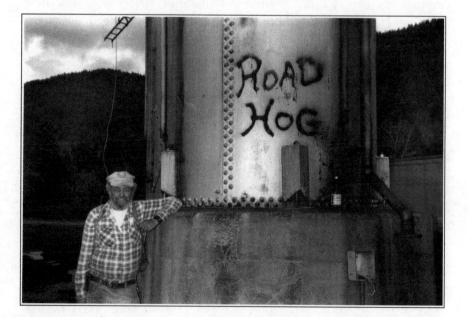

## HOBO KING PRESIDES OVER DYING WAY OF LIFE

Dunsmuir resident proud of "brotherhood"

REDDING (AP) — He's king of an all-but-forgotten way of life, having been duly elected to preside over the past.

But it's an honor none-theless, and Road Hog USA bears the distinction with pride.

After all, as king of the hobos he's got a lot of work to do during his yearlong reign, spreading the word about a dwin-dling piece of Americana.

Still From *Who Is Bozo Texino?*

Road Hog, 52, known outside of hobo circles as Donald DeSimone, was elected king of the hobos last fall at the annual hobo convention in Britt, Iowa. A hobo for 35 years, Road Hog has, since 1989, pretty much settled in Dunsmuir, where he tends the city cemetery in exchange for living in the caretaker's shack.

As hobo king, Road Hog said he is expected to "represent what real hobos are all about" and be a "servant of the brotherhood."

A true hobo is a migratory worker, part of a historic slice of the American workforce that can trace its origins back to freed slaves and continuing through two world wars and the Depression.

Hobos would hop rides on rail cars to move from one job to the next, traveling north, south, east and west to follow crop harvests and camping in "hobo jungles" to get the scoop on employment prospects and share the fruits of their labor with fellow 'bos.

True hobos were self-reliant and self-sufficient people who followed a code of trustfulness and honesty. They didn't beg or steal and wouldn't accept a meal with out first offering to work.

Road Hog emphasized that hobos should not be confused with bums, drifters, or the modern day "yuppie hobos" who ride the rails for fun.

"They're not a hobo till they knocked on a door to work for food, been jailed for vagrancy, and bit by a dog."

There's nothing glorious about the hobo's calling. It's a hard life filled with sporadic work, no amenities, scrapes with cops, bad weather, few friends and no family.

I don't romanticize the hobo life," Road Hog says. "It's dangerous, dirty and illegal."

Still From *Who Is Bozo Texino?*

And on top of that, the occupation hardly exists anymore. "Hot shot" trains carrying 40-foot truck trailers now travel 300 to 400 miles at a time, giving hobos few opportunities to hop aboard. Railroad police, or "bulls," have become more sophisticated and, perhaps most significantly, there's little or no work.

From the veteran hobos, Road Hog said he learned to sling a bedroll, find water, board trains, get work and other essentials of life outdoors. "They taught me how to wash clothes so I would look clean and get work in town. They taught me how to be self-reliant."

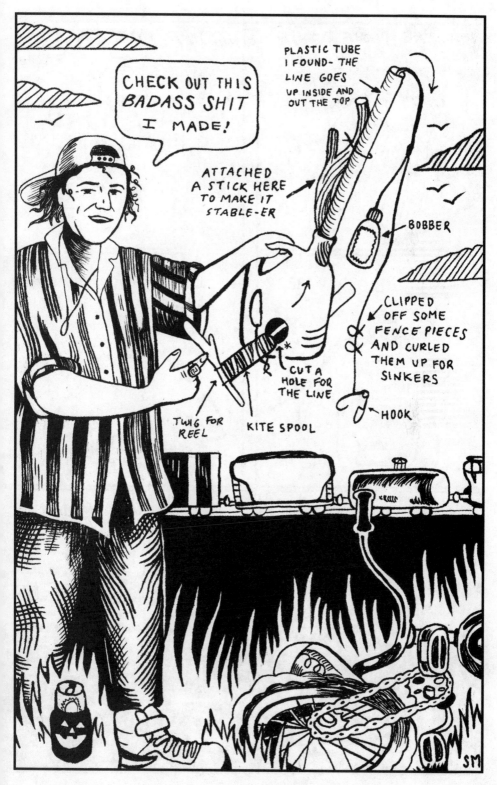

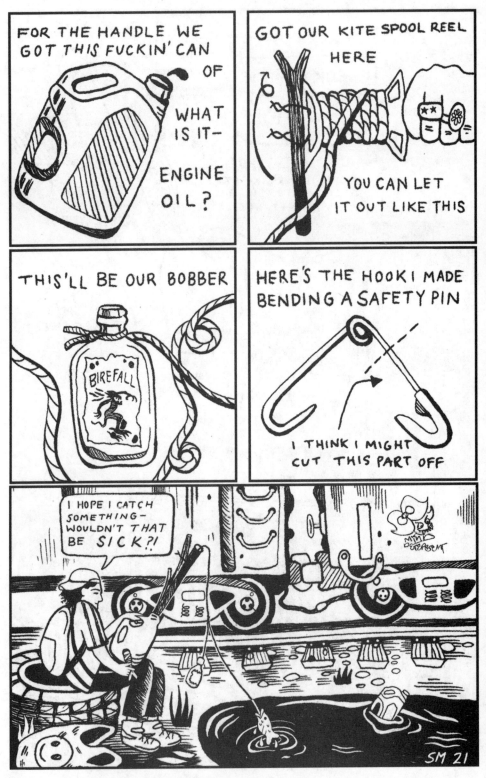

# POETRY

*vagrancy without theory is just loitering*

```
        MORE  TRAIN  GRAF
        or Add 'Em On

   I'm still goin' down to the tracks
     Seein' the messages on the
       rusty brown steel boxcars..
```

TRoJAN Horse

```
        10-7-91

   He wants to sneak in
     and subvert the system.
     Encourage some kid to.

        A great Mex one.
     Is "he" a tree planter?
      A Mexican logger?
      A castration image?
        An amputee??
```

El Truncon

```
        SO LONG HOUND DOGS
        WBL- 11-92

   I get off on just sittin along
     the steel rails—
   Between the elevator and
     the paper mill. Oregon City
     is, was, will be.. my home.

   I walk the promenade above the mill
     and in a circle, up the cement
     stairs past the elevator—
     up Singer Hill. With its
     waterfalls and maple trees.

        (Am I an outcast?  a loner?
        Yeah.  More than ever.
        More than in high school
          or junior high.)
```

*By Walt Curtis*

## "BOZO TEXINO" - *a song written for Willie Nelson*

Bozo Texino is ridin' the rails
from Meteor City to the peyote trails.
He goes to your soul and
he tells you wild tales.

On the side of a boxcar
a man made of chalk,
he's alpha-omega, out for a walk.
He's a son of the stars and a brother coyote
as he walks in the desert
and looks for peyote.

Bozo Texino is ridin' the rails
from old Santa Fe to the white cotton bales.
He goes to your soul
and he tells you wild tales.

He gets in your body
and then runs your mind.
He takes you out travelin'
just to see what he'll find.
He's the different drummer
and he never dies.
He's one with the land, the sea, and the skies.

Bozo Texino is ridin' the rails
from the roof of the White House to the Mexican jails.
He goes to your soul
and he tells you wild tales.

If your mind is made up,and you cannot roam,
don't look at that boxcar, don't ever leave home.
Don't howl at the moon, don't let yourself cry.
Just remember who lives while we have to die.

From Mescalero to the high vapor trails,
he talks to your heart
and he tells you wild tales.
Bozo Texino is ridin' the rails.

By Bozo Texino

## ROAD JOURNAL, 1973

          Milwaukee Road
  Georgia Pacific

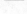

Watch out another train!
(Into Eugene at 2:30)

Trains, workers, all over – keep down...
I wish I could take a look over...

———
      Gawd, I gotta take a piss!

———
What's that sound?

———
     ... faster

———
Oh no! A control tower!

———
(Man, these yards are huge!)

Another control tower!
        (Hope I haven't been seen)

———
And I'm getting pretty hot with all these clothes on, too.

———
    ... Cotton Belt
    ... a whistle

———
slowing, slowing, slowing, stopping.
      ... a blast of air brakes
        (Hope I won't have to wait here long)
      ...train squealing
        ...a whistle

        ...

          ...

            ...

...birds in the distance
...plane
...cars
Voices?

...wait...
...wait...

(imagined men with badges looking for me)
...whistle again
...and again.
Shit, I've got a sore throat.
Tired, too—only about four hours of sleep last night,
    I'd guess.
And my face and hair feel so dirty. My hair is
twisted and tangled and snarled by the wind.
More train noises. Creaks and stretching sounds and
  metal clashing sounds, and leaking compressed air.
  Sounds and bass rumble rhythmic rumbling sounds and
train horns in the distance.

———

A squirt of air and a jerk and now a stretching ing ing sound and
    we are slowly rolling!
Yes, we are rolling out of here!
Still don't dare look—just see tops of telephone poles moving past,
the wheels on the rails sound like bells—each with it's own tone.

———

I sneak a look...safe. Just rows and rows of dirty brown freight cars.
Two men watching—did they see me?
    (Will I ever know?)

———

Another control tower!
Get down quick!
    (Lady bugs on my legs.)

———

Oh no, slowing to a stop again?
      (I hope there's no more control towers.)
An easy, quiet roll—I can't hear the engines at all.

———

Now, faster.
Shadows of overhead telephone poles quickly passing across my body.
And faster.
More noise.
And faster.
More rocking!

And faster.
We're moving out of here!!!
        (I can hardly write, the rocking's so bad!)

—

Two workmen on a bridge see me, point to me.
I wave.
They don't wave back.

—

Finally, out of Eugene! Now, forty-one miles to Corvallis...

By Craig Baldwin

*Some of our readers will recognize Craig Baldwin's name as that of the infamous San Francisco experimental filmmaker. Baldwin's underground, yet influential films include* Stolen Movie, Tribulation 99, Sonic Outlaws, *and* Spectres of the Spectrum. *This piece was transcribed from his original journal.*

# MATOKIE LIVES

*Stories & Photo by Brad Westcott*

Late one night, I was watching a PBS segment called ART21, which had a feature with Barry McGee and Margaret Kilgallen. As I sat there taking it all in, I couldn't help but notice that the car numbers were visible on one

of the boxcars Barry and Margaret were marking. I had recently become obsessive about tracing cars and decided to call in the car numbers and trace the boxcar to see if it was still even in existence. As I sat there going through the automated trace system, I was astonished to find out that not only was the boxcar still in service, but that the exact car Barry and Margaret were marking in the documentary was scheduled to be in my area the following day. Completely dumbfounded, I attempted to contain my excitement due to the fact that this car was marked in 2000, and the chance that their marks would make it through the years unscathed was very slim.

Against all odds, I set aside the entire following day to try and find this needle in the haystack. I traced it later the next morning, just to confirm that it had arrived in my city. Another major difficulty would be actually locating this car. As I set out to try and find it, I considered the plethora of places the boxcar could end up in; sidings, customer spots, and large yards. As I intended to catch this car in the daylight hours, it made sense

for me to start my search at the smaller spots first, then move on to the yards come sundown if I needed to.

I headed to the first spot, and parked in my usual area, far out of sight. As I began to trek towards the cars laid up, I couldn't help but notice a cut of 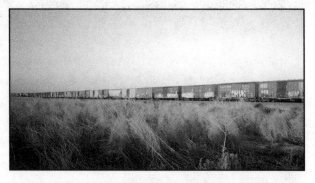 faded red boxcars far down the line. Like noticing a poorly hidden present, I pretended to ignore those cars and take my time walking the line. As I climbed the ballast up to the track, anticipation overwhelmed me. My heart pounded and suddenly I couldn't think clearly. Like being pulled toward something, I quickly scurried past cars which I would normally examine top to bottom, and made my way straight to that cut of faded red boxcars. I just had a feeling that there had to be some sign of Barry and Margaret's marks from 2000!

I will never forget the feeling as I walked up to the first red boxcar. Right there, in front of my very eyes was the very same Matokie Slaughter piece I had seen Margaret mark in the PBS documentary. Unfortunately Barry's mark was sprayed over, and Matokie was barely spared with tags all around her, just inches away from being covered, but her mark still stood out. Before I photographed this car, I sat down in the ballast for a good while staring up at Matokie thinking about the mystery and magic of boxcar art and how lucky I was to be viewing this in person. Could Margaret ever know how much a quick doodle on the side of a boxcar in the East Bay would affect someone thousands of miles away, over a decade later?

This was one of my experiences that keeps my shoulder to the wheel with freight trains. Nothing beats stumbling upon an old mark, but this seemed like fate. Somehow, someway, it just did. As someone who laughs at spirituality and doesn't subscribe to any belief system, I just felt that

this was some sort of cosmic communication occurring. What were the chances this car would end up in my town, at the first spot I checked, after I traced the car on a whim the night before?! The whole experience shook me to the core.

In the years that I've been involved with documenting boxcar art, this is my all time favorite catch. I never knew Margaret, but she is a towering inspiration in all of our worlds, and her devotion to folk art is something that will be cherished and passed down forever. To all of you out there reading this, I will let you know that this boxcar is still in service. Keep your eyes peeled on down the road, and you never know what you may find around the bend.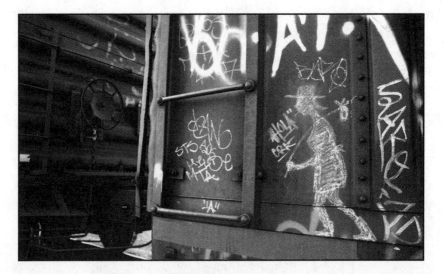

# Margaret Kilgallen

## *aka Matokie Slaughter, META*

*(Regular readers of this publication need no introduction to the legend that is the artist Margaret Kilgallen, (1967-2001.) Margaret, aka Matokie Slaughter, META, M.S. was, and still is, an inspiration to many artists, young and old. — Editor)*

### Mission School -The Messanger's View

By PhotoBill 847

You've probably heard me tell this story before, but I don't care, I'm gonna tell it again. Somewhere between 1989 and 1993, I was bicycle messaging in San Francisco, having recently thrown away a perfectly good career as a freelance commercial photo assistant. What the

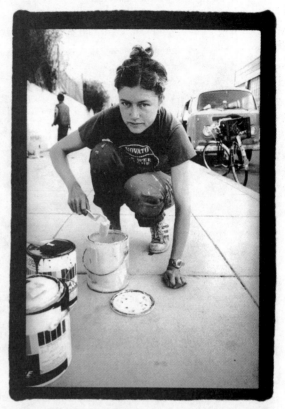

Margaret Kilgallen, Alabama Street, San Francisco, Calif. 1997
*Photo by Michele Lockwood*

messaging job gave me, and every other bike messenger in town, was a front row seat at a fabulous spectacle: the Bay Area graff scene as it was slamming into something that soon would become an art historical movement dubbed "The Mission School."

City graffiti is one of those things, like sub-atomic physics, that's going on all around everybody all the time, but is essentially invisible and practically illegible to everyone other than lab-coated or black-hoodied practitioners. The exception is bike messengers, who observe absolutely everything in the city, right down to the molecular sidewalk poop-pile level. Every morning the bike messenger sees the evidence of nightly artistic collisions before anyone else in the city; before newspaper reporters, before the mayor and his task force, even before the late-sleeping graffiti thugs themselves. And the messenger attuned to emergent scribblers can recite a day-by-day, play-by-play account of graffiti's nightly gains

across the manifold surfaces of the defenseless city.

So, trading my studio assistant's gaff tape and light meter tool belt for Zo bag and a steel frame Marin

most of it I couldn't really recognize— except for some standouts like UB40, DUG 1, Dirt Box, Flipper Rules, Cuba, Minimal Man, Systems Collapse, and Nicaragua, which I later figured out to

mountain bike with a chopped-down metal Wald basket, Continental City Slicker fatties, and a rear fender mudflap made from a Nancy's Yogurt container; I hit the city full force, working for Aero, then Quicksilver Messenger Service, then Perfect Courier, then Western Messenger, then Silver Bullet. (It wasn't unusual to change companies anytime you felt you weren't getting dispatched favorably.) I had found a way to get paid to ride my bike around the city and explore every alley and witness graffiti's every score. And the graffiti game in San Francisco was ramping up.

I have to admit, I wasn't in the graffiti scene myself, I was just a rabid fan. (a foamer? —ed.) At first,

be the work of Twist, my new favorite artist. Like I said, I really didn't know anything about the actual writers, but then one day—Bam! I picked up the latest issue of *Maximum R'n'R* at the Epicenter zine shop, and there was an interview with TWIST! Punk AF!

Five mornings a week, I'd leave my house (a punk warehousehold called Shred of Dignity on Shipley alley by Harvey's Place) and pedal over to Harrison Street to start work, and already I'd be seeing new graffiti that had popped up overnight. Each workday riding through South of Market was like reading the morning edition of what transpired in the streets the night before—new styles were evolving quickly. Among the new names: Probe, Mr. Element, KR,

*Photos by Bill Daniel*

Dog, Amaze, Boom, Mad Max, L. Sid, Coffee, and those weird figures in the Latin American Club bathroom,

and of course Twist, who was just completely dominating the city with rad new work.

I carried an Olympus XA2 in my bag and was shooting photos of fresh graffiti, from the Financial District to the Mission and all the way out to Ocean Beach. Every day the city was measurably improved with new artwork. And then I started seeing a new hand appear on the scene—writing M.S., or META—a female stick figure variant, often with a banjo. The second M.S. I saw was an intriguing paint pen drawing in the phone booth at the Pier bar, an unlikely spot back then. This cool newcomer girl with the naive, folk-arty style kept popping up all over, and going bigger all the time, and usually appearing right next to new Twist pieces. I was pretty sure they must be out painting together, like every night. Then suddenly it hit me, "Twist has a girlfriend and her name is Matokie Slaughter!"

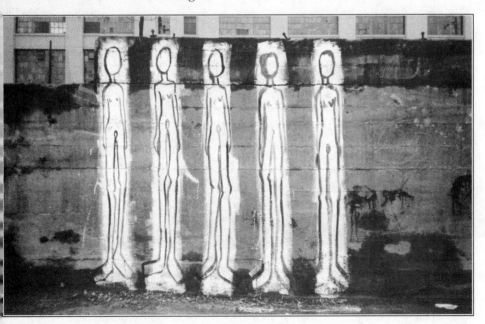

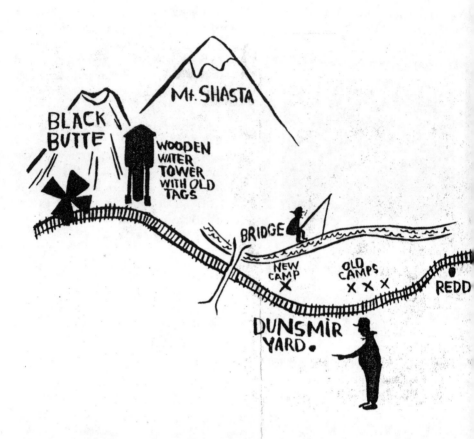

New Camp 6/99

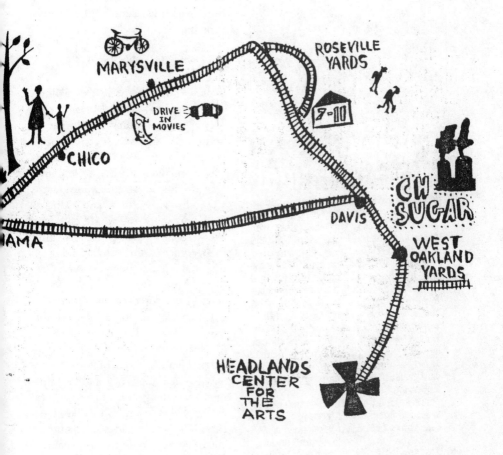

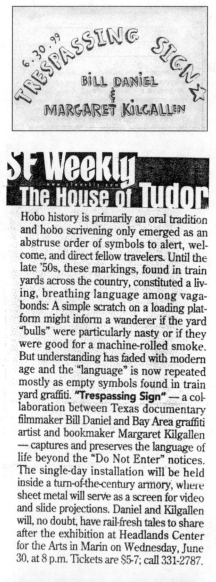

Bill Daniel & Margaret Kilgallen at the Headlands Center for the Arts, June 30, 1999

Review by Scott MacLeod

This was one of the loveliest things I've been to in a while. Miriam Frank was in town, visiting her old haunts here in SF, and we'd met for dinner before heading over to Headlands. It was my birthday, it was a perfect summer evening, a great time for a drive, so there was a softness and a kind of nostalgic air to the whole endeavor. We arrived at Headlands just after their dinner (we tried to attend but it was sold out) and hung out with Greta and Holly. It's nice seeing people you like but don't see that often.

Then as the sun started getting low we all meandered up to the "new" studio spaces up by the Nike launch facility, where Bill and Margaret were having their show. Margaret's paintings were hung in groups in several areas inside the large shed-like structure. The solid shapes of hammers and other hand tools had been painted red on the wall by the entry, the way they'd be in your grandad's garage. Or maybe Margaret hadn't painted the shapes; maybe they'd been there for years. It didn't matter which; either way the painted shapes were perfectly apt and referred to each other and to a specific era, specific attitudes towards work, craft, object & sign. Bill was projecting several films at once, mostly footage of his train-hopping escapades, and there were several slide projectors too, projecting a mixture of archival footage (primarily from the Great Depression) and Bill's photos of hobo signs.

**The House of Tudor**

Hobo history is primarily an oral tradition and hobo scrivening only emerged as an abstruse order of symbols to alert, welcome, and direct fellow travelers. Until the late '50s, these markings, found in train yards across the country, constituted a living, breathing language among vagabonds: A simple scratch on a loading platform might inform a wanderer if the yard "bulls" were particularly nasty or if they were good for a machine-rolled smoke. But understanding has faded with modern age and the "language" is now repeated mostly as empty symbols found in train yard graffiti. **"Trespassing Sign"** — a collaboration between Texas documentary filmmaker Bill Daniel and Bay Area graffiti artist and bookmaker Margaret Kilgallen — captures and preserves the language of life beyond the "Do Not Enter" notices. The single-day installation will be held inside a turn-of-the-century armory, where sheet metal will serve as a screen for video and slide projections. Daniel and Kilgallen will, no doubt, have rail-fresh tales to share after the exhibition at Headlands Center for the Arts in Marin on Wednesday, June 30, at 8 p.m. Tickets are $5-7; call 331-2787.

The hobo signs are mostly fading chalked markings on freight cars, markings which once provided hobos with crucial information about their railroad-centered environment but which are now remnants of a mostly de-signified and obsolete code. What was stunning was that these images

of chalkmarks on rusty metal were projected onto rusty metal—producing incredibly rich visual effects and conceptual resonances with incredibly simple means. The films played against their projection surfaces also; in one bleached b&w sequence, a row of black trees or telegraph poles or structural features of some sort fell into eerie and luminescent synch with the exposed studs of the shed wall it was projected on. And Margaret had painted some human figures, in her usual style, onto Bill's slides, with very interesting results. A grizzled hobo's slumped sitting posture

became a protective posture, arms around a painted female figure. Black silhouettes leaned in boxcar doorways, holding beer or whiskey bottles

and staring into the blinding desert landscape outside. Margaret's men and women, showdy and mysterious, or chalky white and faded like hobo signs, deepened the human dimension of Bill's images. And the situating of her figurative and textural painting within the specific aesthetic and social context of the rails and roads of Depression-era America gave her work a strength and specificity which for me it hadn't possessed before. A successful collaboration between artists; it is a real treat when it happens like it did that night.

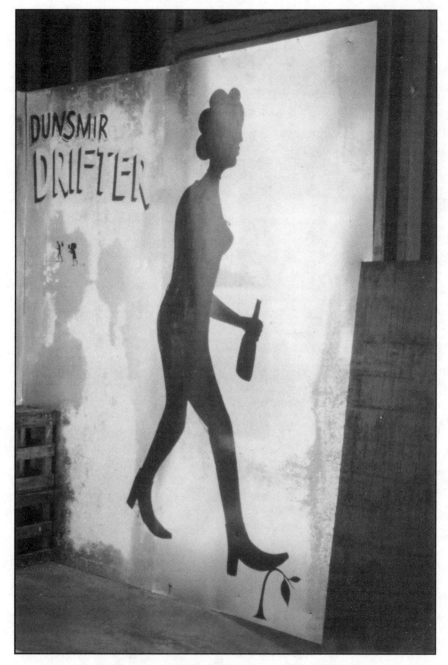

Trespassing Sign, Headlands Center for the Arts, 1999 *Photo by Bill Daniel*

# Mail Car

## Postcards From Cardboard

North Bank Fred Photo by X-TEX

### MissedConnections. (Almost) Riding with Cardboard

By North Bank Fred

"Cardboard", the road name of L. E. McClary, was probably (with the possible exception of Fry Pan Jack), the closest that a person could come to personifying the "real" hobo as I had ever met. There were times that I felt like looking over my shoulder to see if someone was in fact filming a movie about hoboes, with Cardboard the star. A bit of a loner, it took a stroke of luck to be welcomed by him to his jungle. "Cantankerous", though I don't really have an idea of what it means, seemed to be a word made up to describe him. On a hot summer afternoon in the freight yard in Dunsmuir, having nothing more interesting to share with him, I showed him my "union card" that I got at Britt, IA in 1985, and that was enough to break the ice and begin an all-to-short friendship with a truly unique individual.

In the Spring of 1991, we were again sitting in the Dunsmuir freight yard, and he told me his plans to ride out to the National Hobo Convention in Britt, IA, and asked me if I would like to join him. I'd been back there several times and it was indeed an interesting gathering (aside from the slow trains, heat, humidity, mosquitoes, 3.2% beer, etc.) but it would be great to travel there with the "real deal". I told him that I'd love to ride with him, and he said he'd be leaving about the 3rd of the month from So. Sacramento, and we could meet in Oroville. Knowing that the convention is always held on the second weekend in August, I naturally assumed that he meant that he was leaving on the 3rd of August, but I found out, unfortunately for me, that he meant the 3rd of July, so as to have enough time for a leisurely journey across the country.

6-25-91

6-26-91

Hello No. Bank,

Got home ok. Came back with Jackie G. Moon and El Paso. (the El Paso Kid – Ed.) I took El Paso out to the yard Western Pacific so he could catch out to Stockton. Hope he made it. If you get this in time I hope you can be in Oroville CA by the 3rd of July. If you can I will be out by the scale house across from the yard off. There is water and all kinds of good places to jungle there. I been doing it for years. I will have plenty of grub to go with us. I sure hope you can make it. You better bring a water bottle. If you do go with me we will just take our time and see and learn something on the way. You tell Shelly your girlfriend while I was with you and her was the best of the whole trip.
Your friend,
Cardboard.

Hello No. Bank,

Just to say hello and glad you came to con. I didn't like the way the Sacto Kid acted. Fuck him. I got out right where you saw me when you went by on that freight at least it looked like you in a box car going No. The RR went on strike the next day. I been staying out here in the yard in Sacramento for 4 days and last night they started running again at least some Bo's said 3 trains went by. I saw one this morn. I hope so. I want to go to Oroville and stay till 3 rd of July and get out to Britt. I guess the strike is over. There goes another one as I write this card. I don't know for how long. These Bo's has got a big jungle right in the middle of the yard. Wait till the bull sees it. It is a real good jungle too.
Cardboard

7-3-91

8-21-91

Hello No. Bank Fred,
Hope this finds you in good health. I am sitting here by the scale house where I said would meet you and start our trip to Britt. I sure hope you can get here. I was looking forward to it. You look and act like a guy I can trust. Tell your girl friend Shelly I said hello and that was the best part of the trip to the con. Our picnick there in the woods. There is a bunch of great guys that came to the con. But everybody is trying to talk at once and drinking along with it. It confuses me so I try to stay to one side. I don't know how long it's been since you have been in this yard. In another 6 mos. there won't be anything left. The yard off. is gone and they got most of the rip track and the roundhouse is all gone. Next time I go through here there will be be just tracks. A lot of trains still stop here.
Cardboard

Hello No. Bank Fred and that beautiful maiden of yours Shelly. I am out here about a mile from town in the UP yards in Hoisington KS. I wish you were here. I met my friend Don that works for this RR. It used to be in the MP. I got to go back to Pueblo CO and get the B&N to Denver so I can get to Omaha Neb. I sure dread going through Lincoln Neb. It's as bad as No. Platt. I have already been stopped 5 times by the bulls since I left Cal. I waited for you in Oroville Ca. for 5 days and I figured you had a good reason for not coming so I left. I been here for 4 days. They got some wonderful people here. You would really like it here. I got 3 or 4 more stops before I get to Britt. I make friends along the way and enjoy life as I go along. I sure wish you were here.
Your Friend,
Cardboard

# All Around the Watertank

In the days before Markall and Mean Streak, hoboes and tramps carried knives to leave their names on the sides of water tanks where steam locomotives would stop for refilling. These tags date from the 1800s and 1900s.

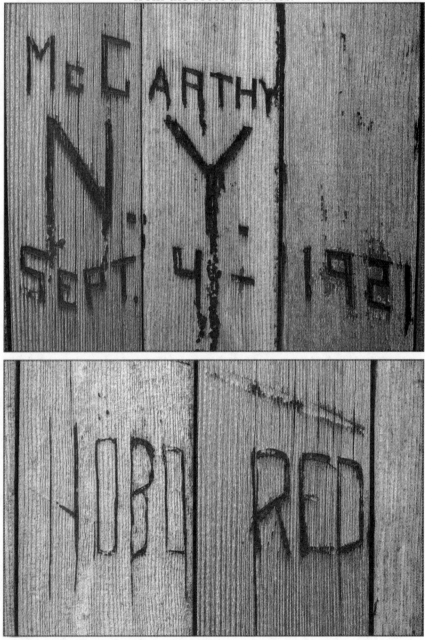

*Photos by Hans Hansen*

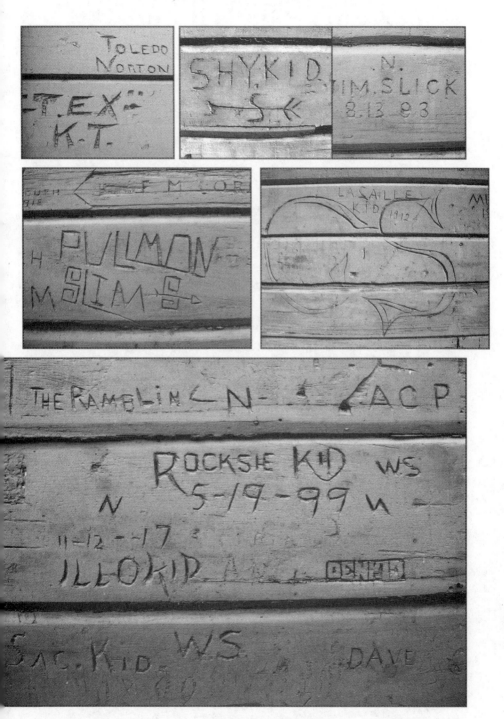

*Photos by Toby Hardman*

# Box Cars High Flat Cars Low

*Come Ride the Rails with Smokin' Joe*

27 JUN 93

I AM THE GUY CALLED Smokin' JOE

I WRITE MY NAME WHEREVER I GO

BOX CARS HIGH FLAT CARS LOW

COME RIDE THE RAILS WITH Smokin' JOE

Smokin' JOE IS MY NAME

WRITEING ON BOX CAR'S IS MY GAME

I DRINK, CHASE WOMAN AND I CUSS

BUT I RAILROAD WHEN I MUST

THEIR. I HAVE A FEW GOOD TAILS ABOUT THE HOBO'S I MET OVER THE YEARS AND A LOT OF RAILROAD STORIES I STARTED A BOOK ON THE LOGO'S ON BOX CARS BACK IN 1984 I WILL BRING IT WITH ME IF I CAN FIND IT. I MOVED A YEAR AGO AND I CAN'T FIND IT. WE ARE GOING TO TIE UP SO I GOT TO GO

HOPE ALL YOUR BOX CAR DOORS ARE OPEN

SMOKIN JOE

# Search for hobo artist Bozo Texino goes on

**W**HO is Bozo Texino? For eight years, San Francisco filmmaker Bill Daniel has sought an answer. He has traversed the country, following leads, interviewing the country's hobos.

And the hobos — the bindle stiffs as they call themselves — have told stories. They said Texino was from Texas and was a migrant worker. Others said he was a conductor on the Sunset Limited. Some said he was dead.

All that is known for sure is Texino is an artist. His trademark — a stylized, yet simple cowboy wearing a wide-brimmed hat — can be seen on freight cars across the country. Below the symbol is the simple, cursive signature: Bozo Texino.

Texino is one of scores of people — presumably hobos — scrawling simple figures, faces or animals on the nation's rail cars. Usually drawn in chalk, the graffiti can travel thousands of miles before dissolving.

Daniel, a Dallas native who has lived in Houston and Galveston, began his quixotic search for Texino eight years ago. He has used a movie camera to film much of the search and plans to complete a documentary about hobo art sometime this year.

"I figured I discovered some kind of secret hobo art movement," recalled Daniel, who lived next to Dallas' Santa Fe rail yard when he first became enamored by the graffiti. "(The graffiti) was not your usual junk. (It was) stuff that looked to be a full-on underground art scene, a boxcar graffiti cult with hundreds of characters — cowboys, drunks, naked ladies."

Bill Daniel

He said he would sometimes spend days with the hobos, filming their haunts and the graffiti he found on boxcars.

From San Francisco, he came across more leads. Daniel followed them to Beaumont, St. Louis and other U.S. cities, but it was in Temple, Texas, where he received his biggest clue.

A Temple resident produced a 1939 Railroad Stories magazine identifying Texino as Laredo railroad engineer J.H. McKinley, who made a name for himself by tagging thousands of railcars with his odd graffiti.

But the McKinley of the article died in Pleasanton, Texas, in 1967. The article provided no clues as to who might be using the Texino graffiti in the 1990s.

Recent leads have indicated that the new Texino, the artist behind the graffiti that continues to grace the nation's freight cars, may be from Houston. Daniel plans to bring his search back to the Lone Star State soon.

"I'm still looking," he says.

Anyone with information about Texino's whereabouts can contact Daniel at P.O. Box 881771 San Francisco, Calif. 94188

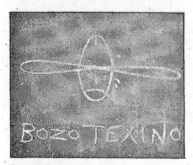

Bozo Texino trademark decorates a boxcar.

**R.A. Dyer**

# Who is Bozo Texino?

*Know-it-all, tell-it-all Texans*

About 15 years ago I worked for a local RR here in Houston, The Port Terminal Rail Road, or as we called it the PORT. I saw numerous cars in the switching yards with Bozo Texino on them.

I believe you will find your artist at one of the plants that is serviced by the PORT. I clearly remember rail cars going into plants or sidings with no Bozo on them, and then seeing them come out with the logo. My memory fails me to recall just where I saw this.

Good luck,
Grady Bryant
Deer Park, Texas

P.S. If you do find out, don't go public, it would spoil the legend. Find the facts but keep them back.

———————

On Saturday May 23, 1992, The Houston Chronicle had an article regarding your efforts to Identify Bozo Texino. I have wondered about that guy myself. I worked for Santa Fe Railroad for 42 years. The first 21 years on the Plains of West Texas and Eastern New Mexico. The last 21 years in Houston, Galveston and Temple. I retired in August 1990 as trainmaster in Temple. Now I am operating a consulting service. Anything to just stay around a railroad.

I can not remember when I first noticed this design. Must have been about 1955 when I was working in Lubbock. The first several years the design was only on AT&SF bulk grain or potash hopper cars. The one thing these cars had in common was both were unloaded on the Gulf Coast of Texas. If the design was on grain cars only, Bozo could have been in Houston, Galveston or Beaumont. I have seen Bozo Texino freshly written on AT&SF covered hopper cars returning to Carlsbad, New Mexico after unloading at the Port of Houston... This would place Bozo only in Houston as potash was only unloaded at Houston.

Two types of railway employees use chalk in their work, switchmen and car inspectors. These large sticks of chalk were carried in the hammer pocket on the right leg of their bib overalls. Switchmen used chalk more often than car inspectors. Destinations of cars, track numbers and other information was written on the sides of cars. Large boxes of chalk were kept in the yard offices and anyone could take a stick of chalk. When crews started getting computerized lists, railroads stopped furnishing the chalk.

I do not believe Bozo was an engineer, an engineer spends his time on the engine. Bozo had to be someone who walked along trains making inspections or switching. Bozo did not have much time as his was a quick signature. He was most likely a switch-

man working the field, a fieldman is a switchman who goes down the track to uncouple the cars. All cars I have seen with Bozo Texino on them were at one time unloaded on the PTRA in Houston.

This is a very interesting hobby you have and I hope you have good luck in these efforts. If I can locate anyone who knows anything about Bozo, I will let you know.

Yours truly,

Henry D. Paulson

Houston, Texas

———————

Let me begin with; I don't know Bozo Texino's name, but I have met him on several occasions. Here is what I know; I was employed by the Houston Belt & Terminal Ry. Co. as a switchman from June 1959 to Oct 1987, when I was disabled by an injury. During this time I was intrigued by boxcar art, some I thought was very well done, Bozo for one, then about 1970 I noticed that Bozo had changed and was not nearly so well done and that I was finding some that were very fresh About 1972 was the first time I met the man doing them. While coupling a track I came upon him coming my way writing on each car with a steel marking crayon (not chalk). He said he started at track #1 and was going to do all 29 tracks (about 900 cars). I did not see him again for several years.

I saw him again about 1975 and this was my first real conversation with him. He came into the shanty at the south end of the yard to get a drink, it was a hot summer day. I asked him

about the change in Bozo and he told me he had known about death of the original Bozo (McKinley) and he was just carrying on the tradition for him. He told me that he was a railroad crane operator for Hughes Tool Co.

The last time I saw him was in 1980 and he said he had retired and was having to buy the crayons he used (he had been getting them from Hughes Tool) and that they were too expensive and that he might quit because the crayons cost too much.

Since crayons for marking on steel last a long time he may have quit and there's just still a lot of them out there.

Sincerely,

Phil Henley

Houston, TX

———————

Years ago when I was employed with the Houston Belt & Terminal Railway as a switchman, there was this old man, retired from Hughes Tool on Navigation Street, that would come on good weather Sundays, driving up to South Yard which was located off Old Spanish Trail and 610 Freeway to the south.

He would drive up in his old '58 or '59 battered green Chevy truck, get out with his chalk box in his overalls and start his art—Bozo Texino on the railcars located in the yard. He moved around slowly from track to track, eventually hitting his trademark on every car possible, took him an hour or so, then you would see him boarding his old Nellie (Chevy truck) and ride off only to see him the fol-

lowing Sunday.

The "old heads" I worked with knew him and spoke of him in that particular yard. At that time, 1978, there were several other "graffitti" markers or artists in the area. The other famous one was a fellow under a palm tree, but I cannot remember his words underneath the picture. Your article brought back some pleasant memories of my times working on the railroad. (which I was permanently laid off in '86) Good luck on finding Bozo Texino. By the way, if he was still living, he would be in his early 80's.

Joe Coroway

---

I don't know exactly where he lives. I have talked to him and he told me that he was retired, he done that just to have something to do. Writes his logo on boxcars anywhere he can. Has material with him at all times on an apron. Talked to him in the 80's. and he was walking so I am sure he lives in Houston.

Sincerely,
F.M.Quincy
Anahua TX

---

I was a car checker at Settegast Yard in 1950 to 1952 and saw many a boxcar come in the yard from the valley area, Brownsville, Harlingen, Kingsville with the Bozo Texino character on them, but it was not the trademark like in the paper. It seems that the person drawing him was a carman around Harlingen area, but he was sitting under a tree like a palm tree. Seems like I read about this in one of the old Mo Pac News Magazines. I doubt if a Locomotive Engineer would have the time to draw the current characters as they are in the cab of the engine all the time. I know this for a fact.

Retired Locomotive
Engineer 1952-1992,
Lou Homer
Palestine Tex

---

Mr. Daniel,

My name is Doug Winchell and I read your recent article concerning Bozo Texino. I travel extensively in the Houston area and am quite frequently stopped at r.r. crossings. I thought I was the only one who paid attention to the graffiti on r.r. cars. I have seen Bozo's logo for several years as well as the martini and several others. I agree with your theory about him being in the Houston area although I always thought it was someone working at a loading facility or a chemical plant. I have no idea as to his whereabouts but am willing to help you any way I can. I'll also read your book when it comes out.

Good luck,
Doug Winchell

---

I just finished reading an article in the Houston Chronicle dated 23, May, 1992. It states in the article that you are trying to locate BOZO TEXINO. I will try and give you all of the information on the TEXINO that I know.

In November of 1968, I came to work at Hughes Tool Company. They had

their own rail system with two locomotive cranes. They also used lots of steel and pipe, thus they received their steel and pipe in railcars. On an average day we received somewhere in the neighborhood of 5 to 15 rail cars.

In early 1969, I noticed the BOZO TEXINO's appearing on rail cars. I started asking questions and found out that one of the locomotive crane operators was putting the TEXINO's on the rail cars.

I was later transferred to the steel and pipe yard, and that is where I met Mr. Lane. At first I was scared of Mr. Lane. He was a very demanding person. Mr. Lane was the kind of person that believed if you have a job to do, do it to the best of your ability no matter how large or small the job. After a slight misunderstanding, we became good friends and from then on, I loved to work for him..

Mr. Lane was born on Sept 18, 1914 and retired from Hughes in October, 1977. He used to call me from time to time, but I haven't heard from him in several years. As far as I know he is still living in a small town called Magnolia.

If I can be of any further help, please write, call or come see me.

My name, address and phone number is below.
Thank you,
Jimmy Dean
Humble, Texas

Dear Mr. Bill,

Around 5pm this evening, a good friend of mine, Vaughn A. Gibson, 2024 Isla, Pearland Texas 77581, phone no. 485-9548, who is on engines, now, for UP, brought an article from the Houston Chronicle (I believe), about wanting a little information about old Bozo Texino.

Vaughn found this article on the board out at the Settegast Yard, took it off and brought it by here and said if I didn't write you, he would.

I got acquainted with Vaughn, in the Belt's New South Yard, which was kind of on my way home where, when I had time, I would go by and mark one, two or 3 hundred cars.

Bozo Texino was written on cars before Mr. Mac put it on his drawing, but anyway, I put Mr. Mac's drawing on a jillion cars, MP cars and all which he was not supposed to draw on MP cars. He sent word by Mr. Sanders (another MP engine man) telling me not to mark MP's. So I started big hat Bozo smoking a quirly.

If you are interested, I am S.A. Lane.

P.S. Be glad to hear from you.

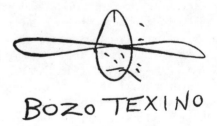

BOZO TEXINO

| BOZO MARKINGS |

| 384-79 USED 40 1STICKS (2ND 8020) | 331 STICKS TO 5TH |

Grandpa and Zelda Texino, 1992 *Photo by Bill Daniel*

# Grandpa

*Front Porch Interview*

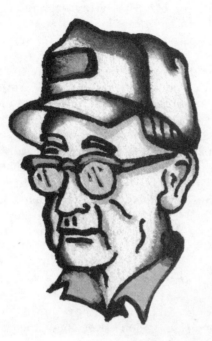

Grandpa *by Kyle Cochran*

**Twenty-eight years ago** in a small oil-patch town in south Texas an anonymous railroad crane operator, known to us as Grandpa, achieved a personal goal that very likely also set a record in the invisible world of boxcar graffiti. Marking his tag on freight trains had been a life-long habit beginning when he was a child in the early 1920s. 60 years later, after his retirement from Hughes Tool, boxcar drawing became a full-blown obsession. On January 1, 1980, he began to keep a daily record of the number of railcars he marked with his signature graffiti—a simple line drawing of a blank staring face below an infinity-shaped hat with the name BOZO TEXINO squarely lettered below it. By December 31 he had, in that one year alone, decorated 30,358 rail cars with the Bozo Texino logo. An estimate of his lifetime total conceivably exceeds 350,000 drawings.

As a kid, Grandpa's father—also a crane operator—pointed out the name Bozo Texino chalked on freight cars. Bozo was a common nick-

name at the turn of the century, not unlike Bubba in the 1970s or Dude in the 1990s. History is unclear as to whether the name Bozo Texino was already in use as a tag then, or if a Mr. J. H. McKinley, an engineer from Laredo, invented the Texino surname when he created a fancy cowboy sketch to accompany it. In either case, by the age of five or six, young Grandpa had seen Mr. Mac's drawing, and began fiercely copying it onto any and all freight cars he could get to. Grandpa claims his father had built him a pair of stilts to help him reach the sides of the cars. Meanwhile in Laredo, McKinley was taking heat from his employer, the Missouri Pacific, for marking on their cars. It seems that even though McKinley only drew on non-MoPac rolling stock, MoPac cars kept rolling in from Houston with Bozo Texino drawings on them. It turned out Grandpa, like any young writer, was hitting anything that rolled with his copy of Mr. Mac's dude. Word came down to Grandpa's father to have that kid quit marking MoPac cars with Mac's drawing. Grandpa, a determined and maturing young artist, said screw that. So he developed his own version of Bozo Texino—his being more streamlined, faster, and using less chalk. Thus Grandpa was able to establish his own character, increase his output, and keep hitting any car regardless of company. The following conversation took place at Grandpa and Grandma's house in 1992.

*Who is Bozo Texino, is that you?*

No, it's just a drawing. Talkin' about these, I'm talkin' about the ones that's marked on one side—I don't ever count them. I count the ones that's marked on both sides of the car.

*So that number, 30,000 drawings in one year, that's actual cars marked, not drawings?*

Yeah, cars. Yeah.

*So for the number of actual drawings we'd multiply that times two?*

That's right. If I didn't get it on both sides I didn't count it. To me it used to be if you marked a car it's on both sides. So, you know, maybe mine's a little different than a lot of 'em. But you know, it's kinda unbalanced just on one side. I wanted to see that people at both sides of the crossing could see it. It's silly, but that's just one of my quirks, I guess.

*60,000 drawings in one year, that's got to make you the top boxcar artist.*

Aw, naw. I'll just say this: as far as the number of cars marked, I don't think too many of them would ever tie me.

**Grandpa** *Photo by Eden Batki*

*What do you think people think when they see Bozo Texino?*

I don't know. It's kinda confusin'. I guess like on mine, if you see a big hat, why, you'd kinda think cowboy, then whenever you'd read the name, uh, I'm sure there weren't too many cowhands with that kind of a name. But I guess the main thing I thought about was that people would see it. "Where did it come from?" They don't nobody care where it's goin', but "Where did it come from? Where were they when they put this on?" I'll say a big percentage of 'em says, "I wonder why that damn fool spends time doing that when he could be doin' something else?" It's silly to some people. I'm sure at different times people wonder, "Who, who marks that?" And then they'll wonder why, and all that crap. Maybe I'm lookin' on the wrong side of it, but, uh, they'd be right, why would a so-and-so waste that much time doin' it? So you got to get enjoyment out of it or you ain't going to do it.

*What did your co-workers think of it?*

They'd just see you doin' it. They didn't make no big deal out of it. But you know, it didn't appeal to most people.

*People didn't think you were strange?*

I don't believe I ever had anybody kid me about it. You know if they did I would have busted their damn jaw. But anyway, I never heard from somebody that said something to somebody about it.

*What made you draw so many Bozo Texinos?*

I got a pleasure out of puttin' on there and I hoped people got a pleasure out of seein' it go by. To me the picture and the name has no earthly meaning. It was just a kind of picture, like I said, one I enjoyed and I hoped other people enjoyed. It has no meaning whatsoever. It means nothing.

"That's Bozo Texino, Taking a Steam Bath"

# Grandpa Texino's Scrapbook

*Golden Memories*

11-10-80

(3) 8758

12-3-80 PROVISO 9-80 AT AN ANGLE

1-5-51 DUNN 6-12-72

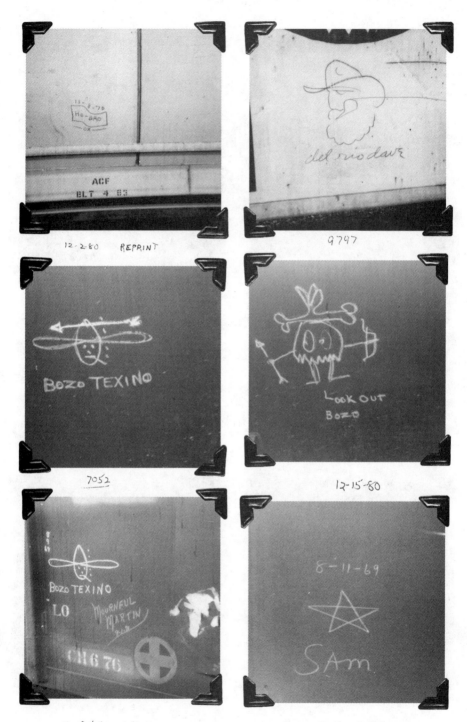

12-2-80   REPRINT

9747

7052

12-15-80

MOURNFUL & BOZO

SAM   12-13-80

2-19-81   DESPAIR

TOADY

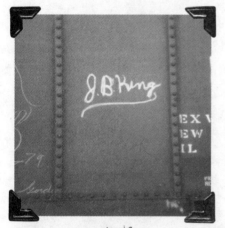

J.B. KING

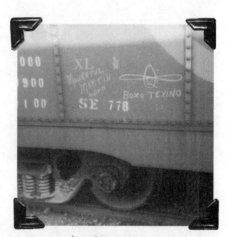

12-2-80   REPAINT

BUY SELL TRADE

OPEN 7 DAYS

1464 GRATIOT AVENUE

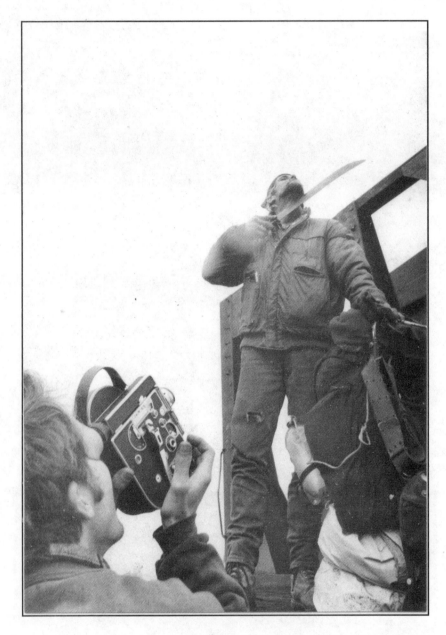

Filmmaker with his trusty Bolex, filming the Butcher, 1995 *Photo Eric Saks*

# Who is Bozo Texino?

**WHO IS BOZO TEXINO?**
**A Film by Bill Daniel**
**56 minutes, Super 8 & 16mm, 2005**

---

**STARRING:**

Grandpa · Dante ·The Rabbi ·
Road Hog USA · El Paso Kid ·
West Coast Blackie · Barry
Brakeshoe · Mainline Mac ·
Tall Man ·The Rambler · New York
Slim · Damnit Ray · Herby · Jack
Flash · Robert · Exum · Texas
Madman · Coaltrain · Colossus
of Roads **and:**

---

**GRANDPA:**

## You could say there was a mystery to it. Maybe you wanted it to be a mystery.

**EL PASO KID**: Where are all these freedoms they talk about? I don't see 'em. You start criticizing and suddenly they wave the flag in your face. You're supposed to shut up. My history goes way back, being a misfit, an outcast, an outsider. 15 years old I jumped my first freight train. I'd hitchhiked before that.

Lot of misconceptions. Most people think hoboing, they're thinking depression years. But it came out of the late eighteen hundreds, now that was Jack London's time. I'll give you a good history lesson.

**DANTE**: I got to get to Florida. And I ain't got no car, and I ain't got no airline ticket, and I got to ride trains, and I got to visit people.

Oh Lord, he gave me a can of chicken noodle soup, made sure I had a couple of dollars in my pocket. Off I went. 3 days later, I'm here. He said nobody goes that fast. Nobody's been that cold.

I got friends who got no leg, got no arm, got no toes. All been cut off by the train.

**THE RABBI**: They call me The Rabbi of the Rails. I got that back in 1974, I was traveling up the railroad tracks by Yakima Washington. A man out there was going into the D.T.s and I just happened to have a bottle of Manichevitz wine. I brought him out of the D.T.s with the Manichevitz wine and he said from this day forward you're gonna be known as The Rabbi 'cause you're the only guy who'd be carrying anything other than Thunderbird or Mad Dog, and you gotta be nuts, either that or be Jewish. That's why the call me The Rabbi from then on. That's the way it is.

We can always put more coffee in there.

**ROAD HOG USA**: Any hobo has a moniker because you never want to use your own name. Different monikers fits different 'bos. I was given the name Road Hog because I'd be riding the units. Some of the 'bos would say there goes Road Hog again. See. So I kinda got that handle that way. That's

a moniker. Other people are Itchy Foot Stetson. He wears a Stetson hat and he's got itchy feet. Frisko Jack, another famous moniker. They call him Cardboard because he takes his cardboard and hops on the grainers, and stuff like that.

**EL PASO KID**: Then you would see people would steal somebody's name. I'm not gonna mention any names, but a certain person used to call himself a certain name and he got it off a guy who rode in the east. Lot of these hobos out here today, a lot of 'em are liars. They love to lie. Somebody will say, "I'm Overcoat Slim", or "I'm Frenchy." I say, "Oh you know Frenchy so and so?" and pretty soon the guy says, "My name's Frenchy..." before the conversation of it ends. All of the Blackies, yeah. Dirty Blackie and this Blackie and that Blackie, it goes on and on and on.

Lot of people are asked their road name and all of a sudden they throw up a quick one real quick. They don't have one. They want to give it to someone to get them off their back they just tell you a name. Pretty soon they're stuck with it.

**ROAD HOG USA**: Like some of these younger 'bos down here, some of them are tramps, some of them are dingbats and mission stiffs and all of that, but part of my job as an older more experienced 'bo

**Self-portrait with Shasta** *Photo by Toby Hardman*

is I want to teach them about this self-reliance and this self-confidence. About when they get to a town that there ain't no shame in walking up to someone's door and say, "Hey, can I do a little work for ya, can I clean your yard up, can I wash your windows?" You know, all that stuff. That makes him a top hobo. 'Cause they got that self-confidence and they got that self-reliance.

**THE RABBI:** I did happen to catch the last Rock Island train that ran out of El Paso. That was 1976, the Bicentennial year, when the Rock Island went out of business. I was headed to Prarieton, Texas. The man told me there was plenty of work there and I caught the last Rock Island out of El Paso. He went 7 miles, stopped the train, came back there and put me up there on the engines. They didn't

know how far they were gonna go before they derailed, that's how bad the tracks had gotten on the Rock Island. They took me into Liberal, Kansas and I hitchhiked down to Prarieton, because that's the only way you can get into Prarieton, and the mayor of the town, that night, when I got into the hotel there, he said, "Son, you came in this town, you was broke when you got here, but if you leave here broke it's your own damn fault." Next day I had a job.

I found out you gotta, you know, wherever you go you gotta keep your record clean, you know.

**GRANDPA:** I don't care whether you like it or not, but I'm gonna tell you right now a hobo is not a bum, and don't you ever call one a bum around me 'cause I'll, you know, I'll get in your eyeball.

16mm Stills From *Who Is Bozo Texino?*

Now, I don't really mean to run a bum down, that's his way and he got started at it. But there's a big difference, and maybe things is changed now, I don't know. But I know how they used to be.

ROAD HOG USA: That's a tramp. He'll come down to the jungle and you'll have a jungle fire going but he won't pick up a goddamn stick of wood to help cook the food. Where a hobo, he'll grab some wood and he'll build a fire, he'll dig into his pockets, he'll pitch in, he'll work, he'll contribute. That's the difference, see. So the tramps ride the rails like we do, see, but they won't do shit. They won't do jack shit. See?

TRAMPS:
Come to party, Come to play.
Tramps ride. Tramps ride out.
Let's do it. You down?
I'm back home again.
Here ya go. *(passes bottle)*
I already done that, Josh.
Let's go ride.
To the ride. *(toasts)*
To the brotherhood.
Kiss Dunsmuir's ass, I'm going.

EL PASO KID: I don't know how they're gonna do it clear on into the future, 'cause I'm telling you it's tough out there now. See, the boxcars used to be all wooden; wooden floors, wooden walls. Pretty soon I can see it, the only way a man's gonna be able to ride,

he's gonna have to move fast, like I can't carry all that truck sack with a lot of food and stuff in there, 'cause I'm duckin through them trains, duckin at night, and climbing through, you can't carry all that stuff, you gotta be able to move fast and be able to hide. Sometimes at night you can do things you can't do in the day-time. Like you just hit the ditch and lay down and not move. They can drive right on by you. You're either gonna have to be light, be able to endure, drink as much water as you can before you get out there. Have a little money on you. Or carry compact candy bars, or sardines in a can, in an old big pocket thing. Insulated coveralls, the though kind, 'cause you may have to be sneaking up on top of things and just laying down, hanging tough, in the wind. Now days you're outside at lot, you're on that cold metal. It gets hot in the summer, too.

TRAMPS:
Lock and load.
Take a little walk and see what we can find.
Always the brotherhood.
Tramps walking.
Here we go.

EL PASO KID: Those were the glory days. You could jump on those trains and ride a few yards with just your clothes on hanging on to a ladder. You got off at the

watertank at the next junction, you rested up, you caught another one coming through. There were so many coming through, they're coming through like subways, man.

You see some of these trains you see today, you see all these grain cars. Now you just think a minute, years ago they hauled all that grain in boxcars. So that meant you saw a whole line of empty cars, man, sometimes 20 tramps get on that train, they had 5 boxcars for each one of those tramps. Get in there, wood floor, and that thousand-mile paper wrapped around there to keep the dew and the rain out. You roll up in there, you could get in with and old suit coat and an overcoat on and lay down and you didn't have to have all this gear you got now. You're not sleeping on that metal.

That used to be one of the best states to ride in, Montana, and that's all changed up there now. People respected you when you were out like that with a bed-roll and everything. Yeah they did it up there. Havre used to be like that, stuff left in the jungles. Now I saw that, what year would that be? '74, '75? I actually saw them do that there, those utensils and keeping that jungle clean and whatnot. Pretty soon people started getting sloppy, started drinking too much. Didn't give a damn.

But if you go do some research on your own you'll find out everything I just told you is true.

**WEST COAST BLACKIE:** Roseville, I can remember when this was a little bitty yard, man. Then they put the hump in down here. You know what a hump is.

You know if I were you, what I would do, it's pretty late in the afternoon, and you know that's about a 12 hour run, to Reno. You're not gonna see that much scenery tonight. What you oughta do is find yourself a good place to camp here, stay tonight, and catch one early in the morning. There's one that leaves about 8 o'clock in the morning. I mean, like you can see all the mountains, you know, the view.

Well ok, I've got a philosophy. Maybe I'm wrong, or maybe my philosophy's fucked up, ok? But there's two things that I do not like and these make me a bum. And that's responsibility and authority. I'm serious. I'll give you anything I've got if you ask me for it. Or I'll do anything you want me to do, if you ask me to. But if you tell me I gotta do it, I don't know what it is, but something inside me says, "Fuck this motherfucker, man, you ain't gonna do it." You know what I mean? And I been that way my whole life, even when I was a kid I couldn't get along…. Oh well, huh?

*(train horn blows)*

I hear ya calling baby but you ain't getting me, not today anyhow. This actually happened. I was living with a broad, a lady. I had lived with her for probably about 9 months. Fox, beautiful blonde, right? And we lived close to the railroad yard. Well where we were we could hear the freight trains at nighttime and I used to hear those suckers after she went to sleep at nighttime and I'd wonder where so-and-so was, what town he was in, who was on the track that I knew, you know what I mean, who was cookin' up a jungle stew and all that bullshit. So I just got tired of the shit.

**BARRY BRAKESHOE:** Yeah, Bozo Texino, him and I got drunk one night. I never drink but that one night I did...

**GRANDPA:** Bozo, see that used to be a nickname, and it was used a whole lot.

**BN ENGINEER:** We just come over the hill, we'll be going into Cheyenne in about 10 minutes. (radio chatter: "... mainline and crew change out front." "Main and change, roger") Ok, Bozo Texino, near as I can figure out from what I heard from people, he works at Coors Brewery in Golden, Colorado. And I first remember, the farthest back I can remember, was seeing a Bozo Texino in 1978 on a car. He might have been around earlier but that's when I first started seeing it. 1978.

*(off camera, "Uh, who's Bozo Texino?")*

**SANTA FE WORKER:** I have no idea.

**HOUSTON STRIKER:** Bozo was a carman, who quit smoking, out of Lafayette, I believe. Lafayette, Louisiana. Whenever he wanted a cigarette he'd draw a picture on the car, to take his mind off smoking.

**ANOTHER SANTA FE WORKER:** We've got a Bozo here, but he just goes by Bozo. He's an engineer, and he doesn't autograph anything. Only engineer we've got who autographs anything is Mainline Mac, and he's pretty notorious.

**MAINLINE MAC:** Well, I know for a fact it was an engineer, John McKinley, out of San Antonio Texas, worked for the Missouri Pacific railroad down there. And he'd drawn it for a number of years also as Bozo Laredo before that.

**GRANDPA:** Lot of people, they don't believe you when you tell them some of this stuff. You know, there's no use to lie about it.

**ROAD HOG USA**: Bozo Texino, he's a bo that rides that low line there, but I seen his handle. But unfortunately I've never had the pleasure of meeting him, I don't recall.

**BEAUMONT SP WORKER**: Who's Bozo Texino? I have no earthly idea.

**TALL MAN**: Oh yeah, he's from Houston, Texas. He signs his name on the sides of the boxcars. But he's a railroad worker. He does the switching and hooks the air hoses together.

**THE RAMBLER**: I'm sure there's a story behind it. But Waterbed Lou is one I would really like to know. I'll bet you that is some kind of a story, 'cause most all railroad men have nicknames, there's a reason behind it.

**NEW YORK SLIM**: Hey Damnit, did you know Palm Tree Herby, the tramp?

**DAMNIT RAY** Yeah.

**NEW YORK SLIM**: There's another person who knew Palm Tree Herby, the tramp.
I believe there was a tramp named Palm Tree Herby, because Catfish was raised by that West Coast Blackie guy, and Catfish don't lie cheat or steal, brother, and he told me about riding trains with Palm Tree Herby.

**BEAUMONT SP WORKER**: Yeah, the little guy with the Mexican hat on, with the palm tree behind it. You don't see much of Herby any more. Herby's getting old.

**HERBY**: Hi I'm Herby Mayer, I used to do this drawing with a plain piece of chalk but when it rained, why, it wouldn't be there the next time, so I started using a paintstick. They used to say I could do it in 30 seconds, but I think that's...
Uh oh, should I change it? It's the 4th month.

*(Herby, how long have you been doing these?)*

Well, Greta said about 37 years, I'll take that figure. It was 1957. I've drawn a lot of them, but not 700,000 like they claim I did. I'd have to spend all my time out in the yard. And I did work once in a while.

*(do you know anything about Bozo Texino?)*

There's a story about that, years and years ago I used to actually see the original hobo, Bozo Texino. Aw, he's been dead a long time. He was an old, old.... This is way back. All these you see now are not the real Bozo Texinos.

**JACK FLASH** I ran into Beam Me Up Scotty. He would sign in like

1896 or 1897. What he meant by that was that he was born a hundred years too late.

NEW YORK SLIM: This Mud Up is Tommy Green.

JACK FLASH: Now give him the significance of who Tommy Green was, who he schooled.

NEW YORK SLIM: Tommy Green, he fuckin' schooled all of us. The original Road Hog, Road Hog USA, older guys like The Flying Dutchman, I'm trying to think. Cold Beer Butch, OK Crawdad, Mojave Don. He was one of the band in the hand. He was responsible for Dogman Tony, Catfish, Arweigian Rick, he kinda raised all of those guys. You ever hear me say, "I don't lie cheat or steal"? That comes from Tommy Green, he coined that phrase. He didn't lie, cheat, or steal, and that's the kind of tramp he was.

EL PASO KID: Well, I wish these new kids luck. I don't stand in their way and I don't criticize 'em. Guess they're the new breed, yeah? Somebody's got to take these guys' place.

ROBERT: Out here's when I'm happy. When I get in society in the city, I'm miserable, man. But you gotta go for a little while, then you get back out here. Like it says in the Bible: To be absent from the body is to be present with God, to be absent from society is to be on a higher plain.

Thing is you can't tell nobody about it. You can see the beauty but you can't describe it in words.

Ain't this nice out here, man? Why can't they let a guy have a couple of acres of that land just laying out there doing nothing. They want you to work 35 years then pay a price for it and then you only got 10 more years to live. That's cold the way things is set up, man, I don't even believe in this here. They say this country is based on hard work and integrity and worshiping God. That's a lie. It's built on murder, man. Mayhem, slavery, oppression, lies, stealin' and killin'. That's what it's based on. And you can't change it after it started. Just stay away from it. Try to get away from it. Be independent of it. Cause if you try to deal in it, you become part of it. Stay away from it, you diminish it by one. By one.

DANTE: My favorite trip was getting on a goddamn airplane and flying home out of goddamn Asia after 3 years of getting shot at.

EXUM: 'Bout the roughest place I ever had to go through was Yuma, Arizona. Now that is a rough town. I seen an old boy that the FTRA jumped on— the Goon Squad. They beat him up bad now. We's all down at the

bus, eatin' dinner by the old Yuma Territorial Prison. Boy come up, said he invited him into camp, he furnished the wine, they dranked his wine, then they jumped on him and whooped him. And they a robbin' and a lootin'. That's what's I heard.

DANTE: I met the old man, the old man's dead, the old man died in Debuke. John Easley is young Coaltrain. Old man Coaltrain is dead, bone, buried.

TEXAS MADMAN: Even if I don't get out but ride me about 3 or 4 hundred miles a year, at least I'm gonna keep the name going. And as far as I know that's all he's doing, is keeping the name going. Here comes something down the tracks! Look out!

EXUM: Alright, on my last trip I run up on an old boy, well I been hearing about this John Easley, seeing his name wrote all over the boxcars and all that shit. Well, I run up on an old boy said that John Easley had stole his name Coaltrain from an old black dude about 80 years old. And this dude says that if he catches John Easley he's gonna kill him cause he's ruined his name. The original Coaltrain is supposed to be an old black man, 80 years old. And also this John Easley, he got in a run in with the bull and so he spray painted the old bull's truck with paint and screwed it all up.

So the bull put a thousand dollar bounty out on him and it took them a while to get him but they got him. I don't know if he's in prison or what.

COALTRAIN: It'll be my luck we'll both end up in the klink.

This is Mister Coaltrain. Some people call him the U.S. Scout. Some people call him a pot head.

You think they'd be happy to get rid of some of these rust spots. You can do this with soap and pencil on jailhouse walls. He's on there, 'till the car goes to the scrapyard.

There was an old guy named Coaltrain. He was and old black guy, he lived in Spokane on the train tracks. And I'd spend a little bit of time, you know, on my way across country between here and Montana, mainly just out to the coal country to work in the summertime, and I used to sit out there with him and I'd say, "Hey you don't mind if I use your name do you?" You know? And he says not at all because when he seen what I was drawing up there and writing Coaltrain on there he was all for me.

They used to come through and hang out at that icehouse. Get their food stamps, double up, whatever they were doing, hit the next train, gone. Back then you still had food stamps, didn't have the card. Now everything's switched to the card. Them days are all

gone too, man. They got that 666, man, it's movin' in. That's what it's all about, that 666 and that world government. They're over there right where they need to get all that shit started at. That Babylon is supposed to be the capitol of the world some day and Sadam Hussien's already got the city built.

**COLOSSUS OF ROADS**: Since November 1971 I have been involved in the dubious activity of fixing images to the boxcars and other rolling stock of North American railroads.

Speed is the thing. Get the maximum number during the working day. You might say it's an expression that they can't buy all my time while I'm out here.

At first approached desultorily, incidentally, the process of drawing with wax crayons a character of comic proportions, who began to take on the aspects of a legend in the fraternity of railroaders, began to reveal the possibilities of the ideas involved. So viewing the railroad system as a network for distributing the image it was pared down to a few simple lines for quick application and easy recognition.

Think now I should start the rap about the origin of this art form? This form of art writing started, I don't know when, but the one that got the attention was during the 30's, and he got some media attention. It was a simply a gentleman signing his name, J B King Esquire. The media theorized that it must have been a hobo. They even picked up on a liquor ad with this name, on a whisky ad, a celebration of the individual.

A new drawing was allowed to evolve with the most rapid, automatic gesture possible for the design. To avoid the redundant commonness of the image I began to put words, names, phrases, antidotes, titles, alter egos, etc, to the drawings. Considered a continuous project altered each day with words help keep me at it, while adding to the idea of chance as the randomness of freight car selection, destination, etc, was already inherent to the system.

Brush Hogs is what everybody else on the railroad calls people from Gurdon, and they may close down the line and we may have to move on, so, Endangered Species. This Altri is Italian for 'other' and Francoboli is Italian for 'postage stamps.' This one is about the strike and is actually Latin for 'I am holding a wolf by the ears.' That was just a big mistake of mine, I'd rather not get into. This Coaltrain is the same person as this John Easley and I heard he was still in jail for spray painting a special agent's pick up truck. Monty Cantsin is the name assumed by a performance artist in New York City, he's actually

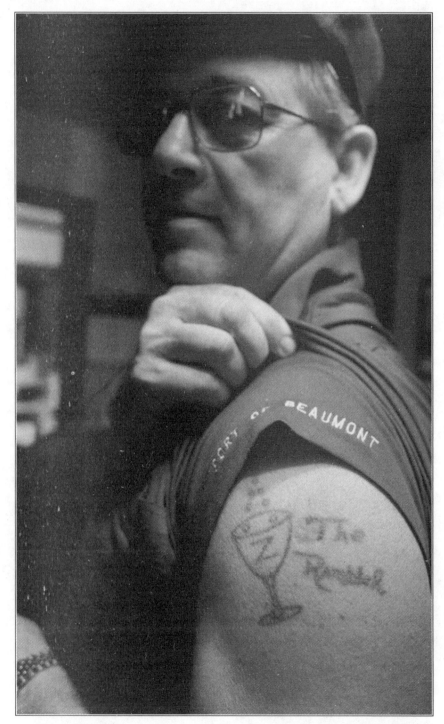

**The Rambler** *Photo by Eden Batki*

a Hungarian and his real name is Istvan Kantor and he wants everyone to assume this name.

Finally the daily historification was ceased and the true precise title, Colossus of Roads, accompanied the image.

More self-portraits than Picasso or Rembrandt or Van Gough or any of 'em out riding the rails. Have a lot larger audience than they ever had in their lifetime.

Well I would say Bozo Texino was at least a 3rd or 4th generation graffiti artist. I'm not aware of his location now, but the original Bozo Texino was an engineer out in West Texas and he made the infinity drawing for the hat brim and the oval for the crown and the face, and always captioned it Bozo Texino. So this has been carried on for at least three generations.

If you're lookin' for the Rambler I would say check Beaumont, Texas.

**BEAUMONT SP WORKER:** All right we got the, let's see, The Rambler from Port of Beaumont, we got The Rambler from Nome, we got The Rambler from Cotton Creek, we got The Rambler from Eams, got the Rambler from China, I don't know if it's the same person or not.

**THE RAMBLER:** All right, you on film? I got it off a sign in Seattle, Washington. And in Seattle they have mixed drinks. You could buy mixed drinks there. In Texas you couldn't do it at the time. So I just happened to remember that, so when I came back, six years later, when I started drawin', we all drank Schlitz at the time out of long necks. So I couldn't draw one. I couldn't draw a damn longneck, it took me forever. So I just remembered that kind of martini glass lookin' deal, and so I started doin' that and it just kind of, boom, fell into place.

I started doin' it in October of '68. I'd moved back to Houston in May and was switchin' and had a bit of spare time down on the lead and so I just started doin' it. I seen all them other things comin' through and so I wanted to figure out something and that's what I come up with and been doin' it ever since. Lot of them guys would go on vacation and say, man, I seen one of your damn drawings in Canada or Mexico or California. I thought, I'll never get there, might as well send somethin'.

**DANTE FUQUA:** Last time I seen his name with a date was like '84, '85, somethin' like that. Ain't never seen anything beyond that. That son of a bitch probably got a whole half gallon of wine and a case of beer and he's sitin' on it and he ain't letting anybody know where it is. That's probably what he's up to. When he gets tired of sittin'

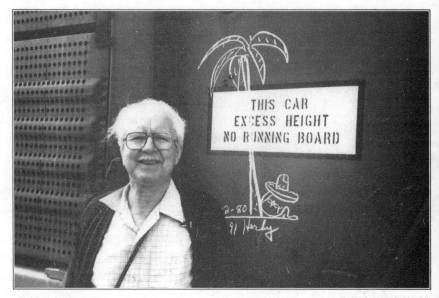

**Herby** *Photo by PhotoBill*

on his butt he'll come back again. I ain't never met him but I seen his signature, but the last time I seen it was like '85 or something like that. Ain't nothin' current, ain't no current address on him, ain't no current cars out there. He could be hiding anywhere.

GRANDPA: Yeah, I'm sure at different times people wonder, 'Who, who marks that?' And then they'll wonder why, and all that other crap. 'Wonder why that damn fool spends time doing that when he could be doing something else?' They would be right, you know, why would a so-and-so waste that much time doing it?

To me it used to be if you mark a car it's on both sides. And then here goes one of those Bozos got it on both sides so either side

they could see it. It's silly to some people. I run locomotive cranes, that was my main job, and switch engines, so I worked on a railroad, per se, I guess that's how you'd put it.

Just a stupid idea. I'm gonna keep my eyes closed. Are you ready?

*(he makes a drawing blindfolded to prove authenticity)*

I got aquainted with it pretty young, I'm gonna say around 5. Of course I was just learning. Like I said, my dad was pretty interested in the name and it kinda stuck with me. That was about 1919 or 1920. (he looks at drawing) How bad is it? Shit, I guess that ain't too bad. I had one boss out there told me one time to quit

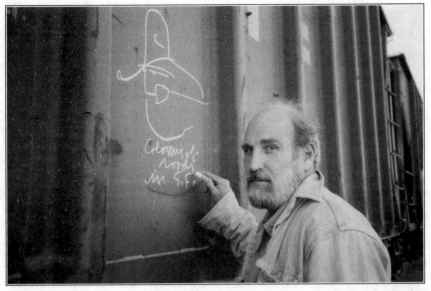

**Colossus of Roads** *Photo by PhotoBill*

markin' them cars. Sure enough, I told him to go fly his damn kite, you know.

In the years after that, now I don't know just when, but Mr. Mac, I believe his name was McKinley, Mac McKinley, I always said Mr. Mac. But he started a picture, and put Bozo Texino under it. And I marked a jillion of 'em with that 'cause I copied him pretty good.

Here's another copy of Bozo Texino. Dennis from Houston. J. B. King. And then the Rose. Cut Eye, he marked quite a few of 'em. Rambler of Smithville. And then Herby. Old Herby again. And then one of my favorites, Mournful Martin. Rambler. And then Hobro marked quite a few. Waterbed Lou. Here's the Laredo Kid. Somebody was kinda using Bozo's hat. Here's a copy of Old Herby (laughs) look how big the trunk of that tree is. Big Apple, that took a lot of paint stick. Here's that bird again. And then the KKK which I used to mark out if I had enough chalk, or paint stick. The Player of Houston. Kite Paste Kid. Gypsy Sphinx, Waterbed Lou. Here's another one, that's real art to me. That's all of them.

Anyway I used to keep track of how many I marked a year, but I can't remember any of 'em except where I went overboard and made a devil of a job out of it and I got to where I didn't enjoy doin' it, and that's where I marked a little over 30,000, in one year. And that kinda burnt me out on markin', 'cause there at the last I sure didn't enjoy doin' it.

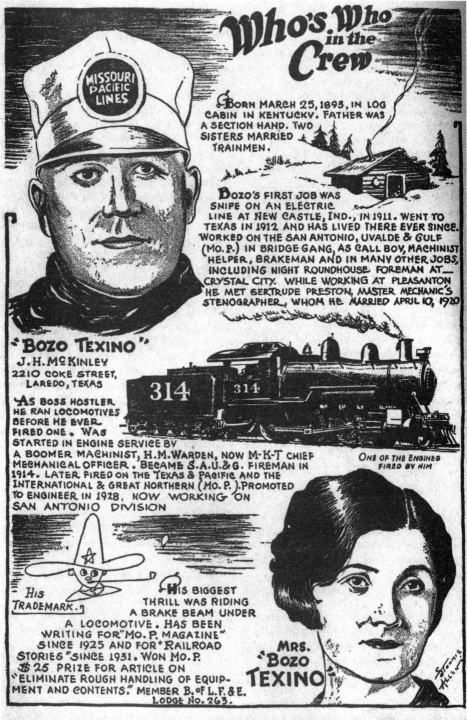

## Who's Who in the Crew

BORN MARCH 25, 1893, IN LOG CABIN IN KENTUCKY. FATHER WAS A SECTION HAND. TWO SISTERS MARRIED TRAINMEN.

BOZO'S FIRST JOB WAS SNIPE ON AN ELECTRIC LINE AT NEW CASTLE, IND., IN 1911. WENT TO TEXAS IN 1912 AND HAS LIVED THERE EVER SINCE. WORKED ON THE SAN ANTONIO, UVALDE & GULF (MO. P.) IN BRIDGE GANG, AS CALL BOY, MACHINIST HELPER, BRAKEMAN AND IN MANY OTHER JOBS, INCLUDING NIGHT ROUNDHOUSE FOREMAN AT CRYSTAL CITY. WHILE WORKING AT PLEASANTON HE MET GERTRUDE PRESTON, MASTER MECHANIC'S STENOGRAPHER, WHOM HE MARRIED APRIL 10, 1920

"BOZO TEXINO"
J. H. McKINLEY
2210 COKE STREET,
LAREDO, TEXAS

AS BOSS HOSTLER HE RAN LOCOMOTIVES BEFORE HE EVER FIRED ONE. WAS STARTED IN ENGINE SERVICE BY A BOOMER MACHINIST, H. M. WARDEN, NOW M-K-T CHIEF MECHANICAL OFFICER. BECAME S.A.U.&G. FIREMAN IN 1914. LATER FIRED ON THE TEXAS & PACIFIC AND THE INTERNATIONAL & GREAT NORTHERN (MO. P.). PROMOTED TO ENGINEER IN 1928, NOW WORKING ON SAN ANTONIO DIVISION

ONE OF THE ENGINES FIRED BY HIM

HIS TRADEMARK.

HIS BIGGEST THRILL WAS RIDING A BRAKE BEAM UNDER A LOCOMOTIVE. HAS BEEN WRITING FOR "MO. P. MAGAZINE" SINCE 1925 AND FOR "RAILROAD STORIES" SINCE 1931. WON MO. P. $25 PRIZE FOR ARTICLE ON "ELIMINATE ROUGH HANDLING OF EQUIPMENT AND CONTENTS." MEMBER B. of L.F.&E. LODGE NO. 263.

MRS. "BOZO" TEXINO

*Next Month* ("Famous Engineers")—J. H. WILLIAMS, Rock Island

# Hoghead J. H. McKinley

*The original Original?*

*Anyone who's spent some time fooling around freight trains over the last hundred years has undoubtedly encountered the moniker Bozo Texino. These days a Bozo Texino tag is liable to be written by just about anyone, but the name and sketch originated with a kid who was born in the Appalacian moonshine country and moved to Texas where he built a legend as a flamboyant engineer, an author, and a graffiti artist. Charlie Duckworth shares this introduction to McKinley from his research, with additional material from R. J. McKay and Andy Dreamingwolf.*

James Herbert McKinley was born in a log cabin in Clinton County Kentucky on March 25, 1893 to Charles Ellis and Rachel Neathery McKinley. He was a second-generation railroader as his father was a section hand. His two sisters married trainmen.

He started his railroad career when he was 17 as a switchman for the interurban railroad Indianapolis, New Castle, & Toledo Electric Railway at New Castle, Indiana but quickly grew a dislike of working in the Midwest winters and traveled south to Texas in 1912 when he was 18. There he found a job with the San Antonio, Uvalde & Gulf Railroad (S.A.U.& G.) on a Bridge & Building gang. He held several positions on 'The Sausage'; a Call Boy, Machinist Helper, Brakeman, Night Roundhouse Foreman at Crystal City and worked other positions as well. He was promoted

to a locomotive fireman in March 16, 1914 and typical of railroad boomers of the period, were they'd travel to any railroad offering more work, he hired on with the Texas & Pacific as a fireman and later went to work for the International-Great Northern Railroad (I-GN) firing at Laredo, Texas.

While working at Pleasanton, Texas he met Gertrude Preston, the Master Mechanic's stenographer, whom he married in April 1920. After their marriage to Gertrude they owned a home in Laredo at 2210 Coke Street just six blocks from the I-GN station.

In 1944 he sold a story 'Spoofing a Spoofer' to the Brotherhood of Locomotive Fireman and Enginemen's Magazine for $10 which was printed in their November 1945 issue. As with Hubbard, not all his stories and articles were accepted as he'd sent a story to the above magazine titled 'A Homesick Boomer' and received back a rejection letter from the editor stating "..our members and other readers take more kindly to stories relating to actual experiences with the comics omitted...".

Obviously undeterred, McKinley continued to write for many years after.

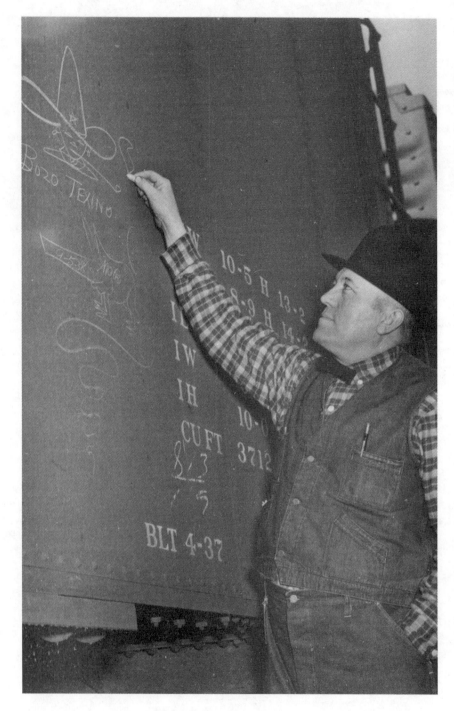

J. H. McKinley as Bozo Texino *Photo courtesy Institute of Texan Cultures*

# Uncle Tom's Caboose

Bozo Texino
Shows Us the
Boomer
Headquarters
in Laredo

By

## THE ENGINE
## PICTURE KID

PERSONALLY I am down in Texas looking for a Missouri Pacific hoghead named Bozo Texino* who has autographed more box cars than Babe Ruth has baseballs. Being an engine picture fien' I am naturally interested in getting shots of motive power, and Mr. Texino has promised to put me next to some good stuff on the I.-G.N., the Tex-Mex, and the Rio Grande & Eagle Pass. All of these pikes do business in his border town of Laredo.

Swinging myself and camera out of an empty gondola as the freight pulls into the Mop yards, I can see this is the

*EDITOR'S NOTE: *His real name is J. H. McKinley and he lives at 2210 Coke St., Laredo, Texas.*

place. Every car in the garden has got a picture of a man with a long pipe in his mouth and a 10-gallon hat on his head.

This is Bozo Texino's trademark. It has been seen and recognized by home guards and boomers all over North America on account of Mr. Texino has put it on maybe 100,000 freight cars in his day.

As I am standing in the yard looking around, a railroad bull eyes me.

"Say, 'bo, gonna be in Laredo long?" he says pleasantly. "We got a nice town. The jungle's two blocks down in that mesquite holler."

Of course, I am no hobo at present, but nevertheless I am glad to see that railroads officials are beginning to take a broader view of a man with a camera

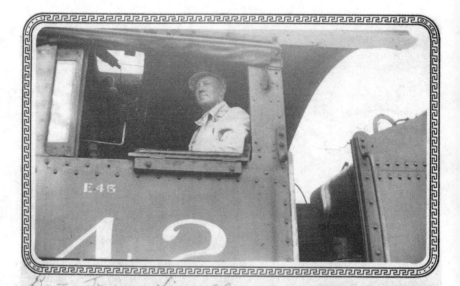

*Bozo Texino - Himself*

## "You're Nuts; There's No Bozo Texino"

BOZO TEXINO

I SAW Bozo Texino's trademark on several cars at the Boston freight terminal of the New Haven the other day. My hogger said to me: "You're nuts, there is no Bozo Texino." How about it?—J. B. CAMPBELL (B. of L.F. & E. No. 57), 6 Blackwood St., Boston, Mass.

(EDITOR'S NOTE: *Your hogger is wrong. There is no Santa Claus and no Stork, but there IS a Bozo Texino. We've met him personally. His real name is J. H. McKinley, his address is P.O. Box 564, Laredo, Texas, and he is an engineman on the Mo. P., now firing oil-burners in Laredo yard service and writing a humorous column regularly for the Mo.P. Magazine. For the benefit of women readers we add that Bozo is tall, well built, clean shaven* and rather handsome—but alas! happily married. Even though the trademark shows a pipe, he never smokes.)

\* \* \*

IN a month I have seen 30 cars decorated with Bozo Texino's trademark (*shown here*). Some new engines for the S.P. have passed through on the way to their steady jobs. How many trains are made up for St. Louis in the Laredo yard where Bozo works, and what are their symbols?

Speaking of packing in journal boxes, about which Bozo had an argument some time ago, the Pennsy's new auto cars have copper wire in wool packing.—C. J. BROWN, 2119 Harvey Ave., East Liverpool, O.

\* \* \*

TELL Bozo Texino the bums are stealing his stuff. They are chalking his picture and name under all bridges around here.—K. P BAYNE, 2975 Leward Ave., Los Angeles.

"That's Bozo Texino, Taking a Steam Bath"

# Bench Report

BOZO'S moniker was chalked on the side of a boxcar I unloaded recently; consigned to my employer, John Deere Plow Co. —R.E. Howser, 1124 S.31st, Omaha, Neb.

\* \* \*

WHILE unloading freight for Sears, Roebuck & Co., from N.P. car No.30090 I saw on the side of the car a figure in a 10-gallon hat labeled "Bozo Texino"
—N. MacLure, 1716 Grand Ave., Ridgewood Park, N.J

\* \* \*

I SAW Bozo's trademark on both sides of P.R.R. car No. 124483 on May 21 in the yards of the Grasselli Chemical Co. at Spelter, W. Va., where I am weighmaster. —Chas. Wood, 748 Hood Ave., Shinnston, W. Va.

\* \* \*

INSIDE a box car I saw Bozo's trademark. It made my feet itch, so that for 2c I'd jump my job running a tractor hoist and take to the road. For years I knocked around the country on freights. I worked down in Bozo's country hauling grapefruit from San Benito to Houston.—John Dayton, 305 Palisade Park, N.J.

\* \* \*

I'VE seen Bozo's trademark on a car as far south as the Colonia railroad station in Mexico City. — David De Porte, 107 S.Pine Ave., Albany, N.Y.

\* \* \*

IN N. Phila. I saw "Bozo Texino" on P.R.R. boxcar 98545. —Geo. Schoup, 65 14th St., Hoboken, N.J.

\* \* \*

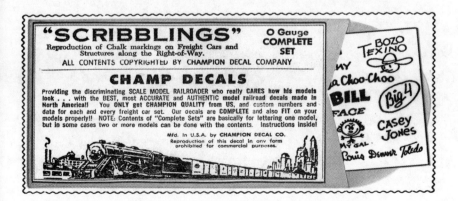

March 13, 2023

Dear Bill,

My name is Lee Carrera. I live in La Marque, Texas. I grew up in Hitchcock Texas which is about 6 miles away. I have lived near railroad tracks all my life. About a year after I got out of the Army I got a job as a laborer on the then Santa Fe railroad in Galveston, TX. This was in July 1973. It was at this time that I first saw BOZO TEXINO on the side of freight cars. I became fascinated with him and the simplicity it took to draw him. I have always liked to draw. Little by little I began to practice drawing him on boxcars that came to the shop for repairs. I did it on the sly and never let anyone see me draw it. I don't know why, I just did it that way.

In 1978 I was promoted to car inspector and sent to work in the trainyard. There I worked outbound trains and inspected inbound trains. This was all done on foot. I worked shift work. It was mostly just me and my co-worker. Him on one side of the train and me on the other. Sometimes it was just one of us. At first I just used regular chaulk but it would wash away with the first hard rain. Then I discovered the industrial oil based markers.

144

with these the drawings can last for years. I worked in the trainyard in Galveston until I got laid off in April of 1983. I don't know how many drawings of "BOZO TEXINO" I made during that time but it was a lot.

I was laid off for about 9 months when I hired on with the GH&H Railroad (GALVESTON, HOUSTON AND HENDERSON) there in Galveston. It was a shortline railroad that was part owned by the Missouri Pacific and Katy railroads. "Katy" was short for Missouri, Kansas and Texas railroad. Anyway, it no longer exists. It died out when the Union Pacific bought out both of those railroads in the late 80's. I worked in the trainyard there as a car inspector and continued my drawings until my work was moved to Houston in 1989. I worked at the Settegast and Englewood trainyards until 2001 when I transfered to Strang yard in La Porte, TX. Once I got to Strang yard I was able to continue my drawings of "BOZO TEXINO". By this time the car inspectors were riding 4 wheelers to inspect trains.

I forgot to tell you that while I was working at the Englewood yard I met the "RAILDOG" artist.

I worked at Strang yard until I retired in January 2011. I put in 37½

working for 5 different railroads. I could have continued working but I felt that 37½ years was enough. In the article and DVD you sent me it says that no one knows for sure who the original "BOZO TEXINO" was. I don't know either. My guess is that he had to be a car inspector or maybe a yard clerk. In the old days, yard clerks would walk the train yard to get a list all freight cars in the yard. Someone who was on the ground a lot. Like me. Someone who was in constant contact with freight cars. After I got good at it I could draw "BOZO TEXINO" in less than 10 seconds. It had to be like that for someone to draw "BOZO TEXINO" on hundreds if not thousands of freight cars over the years. I believe that by time I started drawing "BOZO TEXINO" the drawings I saw had to have been from the 50's & 60's. I just thought about him so much that I wanted to continue what he started.

I live near the Union Pacific main line railroad tracks. Sometimes when I get caught by a train at the railroad crossing I look at the freight cars as they pass by. I don't see "BOZO TEXINO" anymore. I hope that someday I'll see a fresh

drawing of "BOZO TEXINO". That way I'll know that someone somewhere cares enough to continue what he started and that I kept going into the new century. By the way. How did you get my name and address. Makes me feel like maybe someone knew I was the one who was drawing "BOZO TEXINO" on those freight cars. Sorry I didn't respond until now but I really never even thought about it till now.

yours truly
Tex Carrera

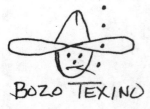

BOZO TEXINO

P.S. My wife was cleaning out the storage shed and found the brown envelope you sent me in August 2006. That's why I decided to write you this letter. You don't have to write back. Just something I thought you might be interested in.

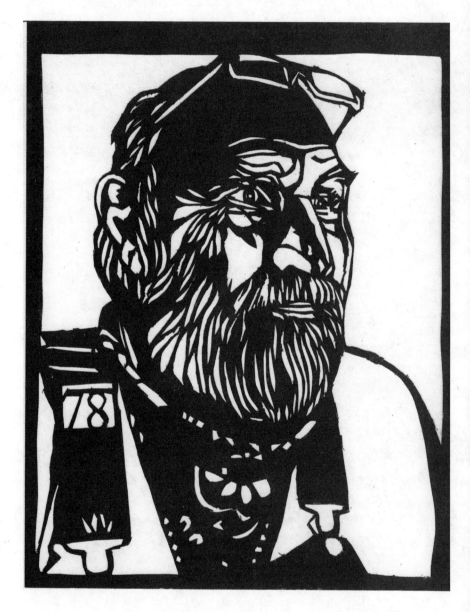

Age Progression, 78 *by buZ blurr*

# Colossus of Roads

*Breakman of Monotony*

### Interview by Blake Donner

*You have been writing graffiti on freight trains since 1971. When did you notice aerosol art on freights, and what were your first impressions?*

The real onslaught of aerosol started in the nineties. At first I wouldn't draw on a car already sprayed...Snob, I suppose, but I didn't want my work to be associated with the spray assault. Gradually, it became apparent if I was going to continue my own margin of cars, which was no less individually assertive than the bold irreverent spray, then it would be necessary to try to find a clear spot, eve if it was on the ladders.

Russell Butler *by Kyle Cochran*

*Why didn't you want your work associated with aerosol art?*

Coming from a long tradition of chalk and paintstick graffiti, practiced mostly by railroad employees, although motivated perhaps by a sense of alienation and animosity towards the railroad, nevertheless, knew that for their art to be tolerated, they had to keep it on symbiotic relationship, and not be disruptive or malicious. Apparently the spray practitioners had no qualms bridling their expressions as they were covering the car numbers and sir date records, as well as the work of longtime graffiti artists.

As another isolated individual, in a vast system of cold practically, I felt a certain kinship with self-expressive outrage release towards social in-

equalities, but at the same time, I had a vague sense of fear that I could be easily pinpointed and punished. This paranoia, plus the awareness of the railroads' hostility towards graffiti, since it hastened their enormous expense of applying AEI (Automatic Electronic Inventory) transmitters on every car, and the installation of AEI readers in every yard (account spray graffiti had gummed up their system of video cameras to compare the actual consist of the inbound trains against supposed consist in the computer) gave me pause to reflect on my own graffiti. It wasn't meant to be provocative proselytizing for revolution, but merely boxcar icon sloganeering as an equilbrium device for my own sanity.

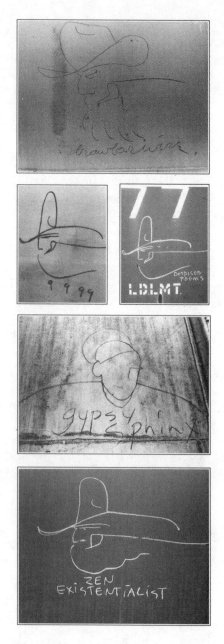

"Change the world; you'll only make matters worse," as John Cage said. And certainly for the worse. In my case, I should be busted—a Zen Existentialist seeking harmony and peace, not discord. Extreme Narcissist Deflecting Blame. I utilized spray to a degree in my graffiti by cutting stencils into eight and a half by eleven collages, then spray painting through them with white paint on dark cars until the stencil became too laden with paint, then flat black the stencil for reduction to stamp-size on the photocopier to be composed into stamp sheets as documentation of the dispatch. I had a delusion I could sell some as an edition, but cnded up sending them out as exchange with other mail artists and stamp makers. Slay Spray was only one such stencil I ap-

plied to spray that had covered my own icon, as retaliation for this disrespect. I have since abandoned this practice. Most of the stencils were done in the late Eighties.

*Do you think that aerosol graffiti and the type of graffiti you do could coexist in the long run?*

Of course... It must. To keep it free, even if it must be done surreptitiously; the boxcar has evolved into a public forum. Aesthetically, it might be offensive and ugly, but we must remember which side of the Berlin wall carried the graffiti. Until we become a police state, and Big Brother has us all under surveillance, there will be graffiti, given that it is highly unlikely we'll ever achieve the utopia of social contentment. Once I stole a quote from someone, to use as a caption to my drawing: "Ina happy world, no one would need philosophers." Later I witnessed one that someone amended with: "Nor fucking train doodlers!"

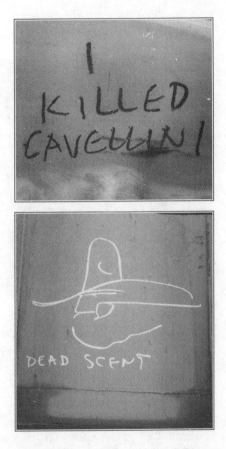

*Who are some of the rail artists that influence you (aerosol and paintstick, etc.)?*

The Colossus of Roads icon design is a variation on the original Bozo Texino drawing. Herby's omnipotent presence in the vast network was an early inspiration.

*What do you mean by calling yourself a "Zen Existentialist?"*

I guess I am saying, as I've said in a boxcar icon caption, "Practice Noncertainty." In a patently absurd world, trust your intuitive guidance for individual responsibility, yet ponder the equation of, "Well, which is it?"

If you have time. Zen quote: "A frog rises up with the same force that he leaps in."

*What do think of death and does it motivate your art?*

O Death! Kafka said, "The meaning of life is that it ends." O Death—won't you spare me for another year! Decidedly, my icon titles frequently refer to Death and Sorry. As my inevitable demise becomes closer and closer, still I harp on the platitude of mortality. Viva Brevis. Papercide Park. The tenuousness of life as thin as a sheet of dissolvable paper.

*Widely Unknown,* Deitch Projects, NYC, Nov. 2001 *by PhotoBill*

It is hard not to despair when you see so many of your icons covered with spray, but the realization of the impermanence of the drawings has always been a constant—now spray is added to the wind, the rain, the sun, which obliterated the lines of admitted resignation.

*So the desire to counteract imperm is what keeps you going?*

Ultimately the transitory nature cannot be counteracted. To maintain a presence in the rail net one must assume the drawings made today are replacing the ones of yesterday, evaporating into the ether. Breakman of Monotony. A Zen Koan says, "If something is boring for five minutes, give it ten. If it is still boring after ten, give it an hour... a day.... A year."

*Approximately how many trains have you painted?*

That would be hard too estimate. I've been on it high on to thirty years. Some days only a few drawings, some days over a hundred. And long stretches of none at all–those periods when I questioned the harm to

my psyche of this obsession. Invariably I returned to this "Equilibrium Device," unable to figure a more productive outlet for my expression.

*Have you ever been caught writing graffiti?*

No—I haven't been hassled or gotten into trouble yet. Perhaps because my father was a respected track maintenance official, and I was only known as graffiti culprit in the lower ranks of management. Now days, with the onslaught of spray paint stuff obliterating car numbers and air date records, they are really incensed about all graffiti even the traditional chalk paint stick stuff that has been tolerated for decades. So who knows? I could be busted any day now since I'm still at it.

Actually, I was caught once by a Special Agent (Railroad Police) who had staked out a cut of auto racks. I was tagging the auto racks when I noticed him at the north end of the cut. Thinking it was a hobo; I crossed over to the other side and began tagging back toward my truck. Almost in a sprint, he caught with me as I was opening the pick up door, identified himself as being a Railroad Bull, and questioned me what I was doing. I told him I was an employee and walked him over to the first car of the auto racks and pointed to the first icon I applied. He recognized it as being a familiar character and said there has been some theft of tires and batteries from the autos since they had started the block swapping in that area. Assured I was only a thief of space and idea, he let me go, and said that my presence could scare off potential thieves and welcomed my continued practice. This was quite some time ago before the auto carriers were enclosed and the aerosol assaults had started.

*You seem very well read... What are some important books to you?*

On the Road, by Jack Kerouac, Nausea, By Jean Paul Sartre, Slaughterhouse Five, by Kurt Vonnegut, Jr., The Politics of Experience, by R. D. Laing, Breakfast of Champions by Kurt Vonnegut, Jr., Duchamp by Calvin Tomkins, Zap Comics by

Russell Butler and Gary Floyd of the Dicks at the S.F. Eagle, 2002 *by Rankin Renwick*

Robert Crumb, Sirens of Titans by Kurt Vonnegut, Jr., The Subterraneans by Jack Kerouac, The Stranger by Albert Camus, Maggie Cassidy by Jack Kerouac, The Grapes of Wrath by John Steinbeck, The Americans by Robert Frank, Wise Blood by Flannery O' Conner, Patterson by William Carlos Williams, Huckleberry Finn by Mark Twain, Being and Nothingness by Jean Paul Sartre, Naked Lunch by William S. Burrows, Tropic of Cancer by Henry Miller, The Winter of our Discontent by John Steinbeck.

*Do you ever paint with partners?*

I have tagged with other people, where it was every man for himself, and I've had people go along as witnesses, but never collaborative drawings with another graffiti artist.

*Do you plan on retiring?*

Yes, I hope to retire from the railroad in two years, but if you mean quit the drawing activity, I doubt if I will since it has turned out to be my major opus.

*Do you have anything to say to the aerosol kids?*

Yes, be free and careful.

*Any last words?*

Vita Brevis!

OUTWARD
MANIFESTATION
OF AN
INNER ESCAPE

# The Caustic Jelly Post Portraits of
# buZ blurr

*by John Held Jr.*

In the April 13, 1972, issue of Rolling Stone, then one of the most popular and influential youth culture American magazines, an article on mail art first appeared in a mass circulation journal. Written by Thomas Albright, the art critic for the San Francisco Chronicle, this "new art school" was described as, "One of the most far-reaching, far-out and potentially revolutionary avant-garde cultural undergrounds." Suddenly, this formerly elusive postal network cultivated by Ray Johnson and others of his New York Correspondence School was laid on the platter of a larger audience upon which to feast.

One of those starved for such a revelation was Russell Butler of Gurdon, Arkansas, who jumped into the expanding network like the open throttle on one of the railroad trains he worked on. Taking on a variety of names, such as Sweeney Todd, Hoo Hoo Archives, and buZ blurr, Butler began mailing out through the Image Bank lists found in FILE Megazine to which he began subscribing. FILE had become correspondence central for the mail art network, and it was here that one of the first mail art controversies arose between long time participants and those recently involved.

Fluxus member Ken Friedman wrote to FILE in the December 1975 issue in an essay entitled Freedom, Excellence and Choice, that, "The pressing onslaught of the latter-day junk-mail movement took the joy out of it for us, and I notice that none of us today engage in much of that sort of work. Why should we place effortful works at the service of persons who dash KWIK-KOLLAGE bits of trash together, printed in the thousands and sent out with little care or concern." Among those kwik-kopy krap artists cited was Butler's Hoo Hoo Archives.

"Most of the stuff circulating now is dandyist posturing against boundaries long ago broken, and it doesn't hold up well," Friedman ranted. "Measure Vautier's FOIRRE TOUT or my own AMAZING FACTS or the first issue of ASSEMBLING against Danielli's L.A. ARTISTS PUBLICATION or the later issues of ASSEMBLING. Given your choice, which would you rather own? Measure the WEEKLY BREEDER of the early years against the latter years, measure them all against HOO HOO ARCHIVES and judge."

To his credit, Butler stood up to the attack and drafted a reply of his own. Rather then retreat from the barbs of a sometimes contentious art scene, he persisted in making art and sending it out. "...recently in grand conceit, Ken set himself up as some omnipotent granddaddy of The Eternal Network in his condescending essay entitled Freedom, Excellence & Choice, then proceeded to tell us, in the vernacular of the CIA, that WE, the troops, had better shape up."

Butler continued, "Again to emulate Ken (Friedman) and drop some names, which is his wont to do, I think when he turned critic he lost all claim to the Pataphyical [sic], a philosophy of Duchamp, George Brecht and even his mentor, George Maciunas, which allows each man to live his life as an exception proving no law but his own!"

Personally, I have learned a great lesson from this and have used it when corresponding with newcomers to the field. Never judge a person by his or her initial efforts. It's enough that the fledgling artist brings an enthusiastic approach to beginning efforts. In time, something may develop. Or perhaps not. But in Russell Butler's case, his activity brought forth a consistent body of exceptional work.

Any of his many accomplishments makes for exciting reading, but I dwell on but one aspect of buZ blurr. His stampsheets documenting mail art gatherings are one of the finest mementoes of the movement, and this essay addresses the methods and history of his Caustic Jelly Post begun in the early eighties.

It was Butler's contention that most of the railroad graffiti of the thirties and forties was not the work of tramps as most contended, but of railroad workers who had access to the main switching yards. Writing on boxcars ("Kilroy was Here" being the most famous) at these crossroads, their work was spread throughout the country at lightning fast speed. Butler continued this practice by writing poetic two or three word phrases on the cars accompanied by a signature portrait of himself in a beard.

Although he had done several sheets of photocopy stamps in the late seventies, buZ found a process he was comfortable with soon after a trip to California. He had purchased an early Polaroid instant camera, a Polaroid 3000, which he began experimenting with. There was much excitement about these recently developed instant cameras. Most artists concerned themselves with the manipulation of the film surface, which was easily distorted before drying. buZ chose a different path.

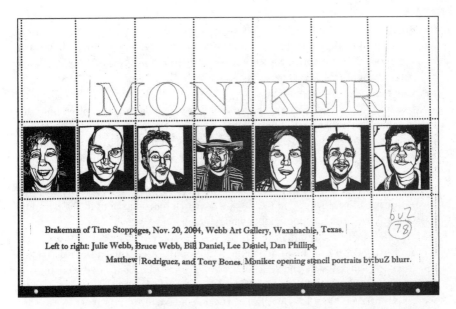

Brakeman of Time Stoppages, Nov. 20, 2004, Webb Art Gallery, Waxahachie, Texas.
Left to right: Julie Webb, Bruce Webb, Bill Daniel, Lee Daniel, Dan Phillips,
Matthew Rodriguez, and Tony Bones. Moniker opening stencil portraits by buZ blurr.

When one took a photograph with the Polaroid, the picture was ejected from the camera covered with a negative image, which one peeled off and was told to dispose of because it was "caustic." Instead, buZ took the negative image, allowed it to dry, and then carved (with an exacto knife) the light areas. The resultant stencil was then placed on a photocopy machine and copied, creating a high contrast portrait. The first portraits created by carving the Polaroid negatives were of buZ himself and his wife Emmy. (True to form, buZ has also created a persona for his better half. She often appears in his stampworks as Earlene.)

Seeking a look like the Man Ray 1930 photograph of Duchamp in profile, the camera was held close to the subject, so that the face filled the frame. This was to become standard procedure for the Caustic Jelly Post Portraits, as they became known. The camera was held only two to three feet from the subject, rendering the subject momentarily blind as the flash exploded in a burst of creativity.

buZ has called the Caustic Jelly Post Portraits "polaroid performances," and they are indeed an interactive experience. "Polaroid Proliferation," "uneven captivas," and "Pictures Virus" are other terms he uses to describe the process. Other such phrases appearing in the texts of his stampsheets include, "fluxus event witness," "briars untie my shoes," "gift of healing carpenters," "rust never rests," "sofa sloth demons of the melancholiac" and "popeye summer of rage."

Aside from this documentary work of other mail artists, blurr also turns the camera on himself each birthday. They are often accompanied by self-deprecating terms such as "glabrous pate acrophobic," and "lyssophobic underwater man." As well as assuming various personas (Colossus of Roads, Sweeney, Hoo Hoo, buZ blurr), Butler has also established imaginary lands in the tradition of many artistamp artists. Surrealville and Principality of buZ are the most often used.

Of all the stampsheets blurr has done, most profound are the stampsheets gathering images of participants attending various mail art events. They serve as a reminder that these meetings are just as important in the mail art experience as postal encounters. Taken together as a whole, they reveal a dedicated trail of meetings with his correspondents.

Mail art deals with the act of shared creativity in all forms. It is often misleading to those unfamiliar with the field, who assume that the totality of the activity takes place through the post. In truth, mail art is an umbrella that encompasses a variety of artistic pursuits including artists books, zines, photocopy, performance, fax, congresses, rubber stamp and artist postage stamp activity.

Creative communication is the central drive of the activity, regardless of the medium used to achieve it. No one in the network has documented the personal exchange in real time as poetically as buZ blurr.

He is known throughout the world, yet his neighbors in Gurdon are completely unsuspecting of his hidden life in the mail. A local friend of his traveling through Europe was shocked to see his work on billboards advertising the artistamp exhibition at the Swiss Postal Museum. He is an unassuming person, who would never blow his own horn. He doesn't have to. His work speaks for itself.

---

# 'Tramps' Deny Any Role in JFK Killing

## FBI interviews 2 of 3 men found near assassination scene

*Washington Post*

Washington

Two of the three "tramps" arrested in Dallas shortly after the assassination of President John F. Kennedy have told the FBI that they had nothing to do with the Nov. 22, 1963 shooting.

Oliver B. Revell, agent in charge of the FBI's Dallas office, said yesterday that John F. Gedney and Harold Doyle were found and questioned recently after years of anonymity. The third, Gus W. Abrams, probably is dead, Revell said.

Their arrest sheets were found recently among Dallas police records on the assassination.

"We're not reopening the Kennedy case per se, but we are factually checking out any leads that do not appear to have been adequately handled," Revell said.

Many conspiracy theorists have said that the tramps were involved in the killing. Clean-shaven and relatively well-groomed, they were found in a freight car near the assassination site not long after Kennedy was killed Nov. 22, 1963.

They were held as "investigative" prisoners on vagrancy charges and released four days later, according to their arrest records.

Gedney, of Melbourne, Fla., and Doyle, of Klamath Falls, Ore., told the FBI that "they had spent the night at the rescue mission and

were treated very nicely," Revell said.

"Both commented that they had gotten fresh clothes, showered, shaved and had a meal. They headed back to the railroad yard when they heard all the commotion and sirens and everything. ... They were told the president had been shot."

The FBI also plans to perform a new image enhancement of an 8mm film taken six or seven minutes before the assassination that seems to show movement in the sixth-floor windows of the Texas School Book Depository, from which Lee Harvey Oswald is said to have fired the fatal shots.

# Emergency Relief Administration

*Your Tax Dollars at Work*

*File here*

EMERGENCY RELIEF COMMISSION
The Most Reverend Edward J. Hanna, Chairman
MRS. HANCOCK BANNING
O. K. CUSHING
JUDGE I. M. GOLDEN
CARL E. JOHNSTON
I. IRVING LIPSITCH
GEORGE R. MARTIN
DANIEL C. MURPHY
DWIGHT MURPHY
JOHN G. MOTT
MAJOR GENERAL F. S. STRONG

R. C. BRANION
EMERGENCY RELIEF
ADMINISTRATOR

H. A. R. CARLETON
DIRECTOR OF TRANSIENT SERVICE
741 SO. FLOWER STREET
LOS ANGELES

### State of California
### Emergency Relief Administration

**TRANSIENT SERVICE**

July 17, 1934

Mr. Wm. J. Plunkert
Federal Director Transient Activities
Walker Johnson Building
Washington, D. C.

Dear Mr. Plunkert:

Please find enclosed herewith copy of "Hobo Journeys" as
compiled by eight special investigators from the University
of California during three weeks of July 1933.

You will recall I promised to send you a copy of this when
we were discussing it on your recent trip to California.
You may keep this copy for your files as I have prepared
an extra copy.

Very truly yours,

Director Transient Service
and State Camps
STATE EMERGENCY RELIEF ADMINISTRATION

HARCarleton
meb
enc

Record Group 69, Records of the Works Progress Adm.
Records of the FERA Transient Division
Narrative Reports and Correspondence, Arkansas - Nebraska
National Archives

"HOBO JOURNEYS"

By Eight Special Investigators

from the

University of California

During Three Weeks

In July 1933

Selections from reports of eight
University of California students, or recent
graduates, who as investigators for the State
Emergency Relief Administration travelled among
the itinerant groups, the last three weeks of
July, 1933. Their names as given herewith in
connection with extracts from their reports,
are shown also in relation to their itineraries,
on the following map.

Supporting data for State plan of
Transient Service
under auspices of

R. C. BRANION

STATE EMERGENCY RELIEF ADMINISTRATOR

(Summarized Sept. 12, 1933)

## SUMMARY OF HOBOING REPORTS

From a brief initial consideration of factors in the transient
situation in California, around the first of July, it was
found that a report concerning the viewpoint and experiences
of unemployed men on the road would be especially helpful in
planning relief measures. Information of this qualitative nature
seemed desirable, in supplementing facts gathered through other
channels on a more statistical and administrative basis.
Arrangements were made for four pairs of investigators,
trained in critical observation, to "bum" their way over
assigned routes, as shown on the preceding map.

As to numbers, it was generally reported that movement of the
transient class across state borders, in and out of California,
at this midsummer period, was at an even rate of fluctuation.
Five or six hundred were thought to be traveling daily, each way, across
across the Oregon and the Nevada lines, north of Sacramento.
Four hundred, or thereabouts, were likewise estimated to be
shifting daily east and west across the Arizona border, in
Southern California.

From the reports here summarized, single men transients in
California appear to be using free transportation, mainly on
the railroads, as a means of tapping community resources for
meager subsistence. Occasionally they get work, for a short
time. Continual traveling, along the main lines of traffic
between San Francisco and Los Angeles, and by way of roads
leading into the State, is necessary among the large majority,
under the universal passing-on procedure. The urge to move
out of town is furthered by a lure of rumored work ahead.

> At Yuma, the straw boss on the work test,
> told us about the rumor that had been spread
> in the East, that free shoes were being given
> away in Yuma, and how inquiries had come from
> hundreds of tramps for free shoes. However,
> (in the matter of unfounded "information")
> he was just as bad, because he told us that
> we could get work on the bay bridge in San
> Francisco. The more distant the place, the
> more certain the informant is that one can
> get work there.

Those who tarry for more than a few days in the "jungles" are
mostly of the older and less able-bodied group. In the larger
cities, especially Los Angeles, many find it possible to shift
about and remain indefinitely.

Much thought was given by the investigators to determining
types, among several hundred persons interviewed, and to
discovering their problems, and their possibilities of
individual adjustment, through a constructive plan such as
might be anticipated under Federal relief procedure.

At the bottom of the stream of transients, following the
age-old ways of vagrancy, is the pre-depression type of hobo.
He constitutes, in the aggregate, perhaps ten or fifteen per
cent of the total. Swinging along with this undercurrent,
are the newer itinerants who have picked up the practices
and interests of the hobo during the last two or three years --
perhaps an additional twenty-five or thirty per cent of the
total. Thus, somewhere around forty or fifty per cent of the
transients in California may be characterized as persons permanently
given over to foraging -- free riding, begging for food or money,
lingering in breadlines and sleeping at inexpensive lodging places.

Somewhat distinct from these more experienced and inured wanderers,
there are great numbers of crop followers, workmen recently displaced
at the skilled and semi-skilled levels, immigrants from other states
who hope to get along in some way, a little better in California, etc.
The skilled appear to be pushing the less skilled into casual labor,
or into the discard. Near the port cities circulate unemployed
seamen - "clean, orderly, easily identified."

All of these groups, except perhaps the pre-depression hoboes,
seem to identify themselves with the existing social order. They
choose ordinary topics of conversation. They are interested in
reports of progress-- under the "New Deal". They talk about
settling down somewhere -- under favorable conditions. While a
large proportion appear to have come from broken homes, they do
not from such disorganizing circumstances seem to have become
"bolshevists". When there is temptation to commit depredations
along railroad right-of-way, the code of the hobo comes in, to
protect life and property. Transients on the move generally
appear to lack gang or mass tendencies to crime; one policeman
can control large numbers. They appear to hold faith that measures
now being formulated under government leadership will better their
situations. "Few carried weapons, and it was safe to sleep in the
jungles, even when it was known that you had money."

Professional bums always will get about on the railroads, without
benefit of the leniency which has been extended by public carriers
during the last few years. They, and the older men who have recently
taken to the road, seem to sanction the idea of prohibiting the present
free riding by boys, with its resulting dangers due to youthful inex-
perience and carelessness. Among boy riders many severe accidents
were recported.

While itinerants benefit from their outdoor life, health conditions
in general are deplorable, due to neglect of diseased conditions.
These include especially, bad teeth, infections of all kinds,
veneral disease, in particular; malnutrition, and the infirmities

of advancing age. Physical unfitness and deterioration are scarcely second in importance to mental trouble. This, in turn, shades off into low morale, which can be generally observed in assemblies of transients at relief agencies, and in the "jungles".

In matching their abilities with labor demands, transients are handicapped in competition with resident applicants, who have better information about the work to be done and who can give local references.

The transient's own solution for getting direct relief - begging, or "stemming" -- has become a racket. Neither are the more worthy ones helped in the pan-handling process, Nor is the burden of charitable donations fairly distributed among those most able to give. The transient's own solution goes further, toward shaping his itinerary, not only in relation to work opportunities, but also in relation to available sources of food, and toward comfortable weather, especially for the night. As transients in California during the summer tend to avoid the colder coast routes, so transients elsewhere, in winter leave more severe climates for "sunny California."

As to community solutions for his welfare, the transient favors relief under public auspices. This attitude arises, apparently, from unfavorable experiences with voluntary agencies, which have been endeavoring to function in the swollen stream of transient traffic. While labor camps tend to be avoided by the professional hobo, they are attractive to a majority of the men on the road, partly because of their reputation for furnishing constructive employment, as distinguished from the work tests of relief agencies.

### EXTRACTS FROM FIELD REPORTS

#### A NIGHT RIDE

Melvin M. Belli

A long hot afternoon fades into a warm evening -- there must be a "freight thru soon". Some of the men in the jungles will wander towards town, being careful to keep from passing thru the yards, hoping to pick up some "yesterdays bread" or a slice of meat for a mulligan with a "say Butch, how about an old bacon butt for a buddy back in the jungles." Some fill an old tin can with the warm water from a hose. The night passes by slowly; it is only from an occasional "I think she's goin' to highball soon Jack", that one is conscious that there are others in the jungle. Some are sleeping on their blankets, others are propped against a sand pile looking at the muriad of stars which shine as fiercely at night at the desert as does the sun in the day. There is no moon but the reflection of the brightest stars makes a soft opalescent glow upon the nearby rails. Green lights glow steadily in the signal posts, welcoming with an "all's clear ahead", as far as the eyes can follow down the tracks, but in the distance their even glow is subdued by the brilliant twinkling of the stars. Where the rails cross there are small red lights close to the ground. They mean switches-- and danger to the man who does not mark their position when he is running for a rung on the side of the freight.

A long whistle, then a short, the tracks are flooded with the strong white light of the powerful searchlight, the eye of the locomotive. An enormous engine is passing over the nearest rails, her light goes past, then everything is dark and it takes a few seconds to become again accustomed to the dimness. The red glare of the fire box is up the tracks now and rapidly going away. All Along the tracks figures appear, coming from the shadows -- they spread out along the cars and find a clear stretch of track to run for a reefer, grab its iron rungs and clamber aboard. It reminds one of climbing into the crows nest on the mast of a swaying ship at night. There the motion is gentle and swaying tho, here it is jerky and tricky.

By the time the caboose passes the last switch and the short jerks and puffs of the locomotive have become a steady rhythmic roar, the figures begin to appear on top of the cars. Up forward the headlight is illuminating the track far into the distance, to become lost in a horizon spotted with stars. Towards the caboose there are huddled figures on each car, swaying as the big and heavily laden "reefers" roll along the tracks.

The fresh desert air is blown across and washes the tops of the cars. The faint odor of burning oil is carried back from the engine and is pleasant. A streamer of maroon colored smoke measures the train from engine to caboose and then is lost on one horizon as the light from the eye in the engine is lost on the other. One entwines a leg under the cat-walk, lies on his back with a coat for a pillow, sways with the motion of the cars, watches the stars and tries not to go to sleep.

### PLAZA SQUARE, LOS ANGELES

From the yards we wandered to Plaza Square. Pershing Square is a step up in life. For the bum it is the distance between the cafeteria and the Ritz. Too, it is dangerous. Police walk thru constantly and one may fall asleep and by staying too long, be uncomfortably questioned as to his visible means of support. However, in Plaza Square none are bothered. Every bench is filled. Like the inmates of a prison or asylum they come early and whatever spark of ambition they had upon rising, to look for a job or the next freight, is dimmed by the glowing sun and soon its warming rays are falling upon a sleeping person.

Most of the bums in the park are receiving aid from some relief institution. Unlike those who never leave the jungles, these men see the city and fall into the life of easy living, if it can be termed that, at the missions. If the life is too easy, they are induced to stay, and wander from mission to mission.

From here we learned about all the possibilities of feed and flops in L. A., and the way to "beat" the managers."

First, In Los Angeles a full meal can be purchased for a dime, and some of the relief institutions give the bum a ticket to eat at these restaurants. But it was the cafeteria we were first told about. "Buy a cup of coffee first, then go back and get your other dishes -- you can eat a whole meal and by telling them you lost your first ticket, you can check out on it when no one is looking and get a whole meal for the nickel check for coffee." This was told us very confidentially, but whether every other bum in the park knew it or whether it would work we never found out.

etc.

## TEXANS

In the yards, just before we caught our freight, we met a long Texan
sitting under the bridge. He was waiting for the passenger train and
was going to ride it "blind" (behind the tender) to San Diego. He
was about 25, fair and clear complexion, good looking; his overalls
covered other clothes. There are many of his type on the road.
They travel fastest because they travel alone; they say little
but are not brusque. Their first words show they are from Texas.
We met five or six of this type, similar enough to be brothers.
They belong to Texas and from their conversation they will go
back.

Etc.

## BULLS

The Santa Fe is the most difficult of the lines to ride, but even
they can be ridden. The city police are the most dangerous for the
bum, in that they are the only ones who will bother to put a vagrant
in jail. They pick up the bums coming into town, but not going out.
The railroad dicks merely keep the men out of the yards and off rail-
road property. They have no sympathy for tramps and show so by their
language and attitude. It seems they delight in kicking over a meal
in the jungles. Many stories circulate on the road about a particularly
tough "dick". One such is "Texas Red" -- a bum killed his father and he
was out to make it tough for the bums. These dicks do not last long,
according to the tramps, for someone will get them, going out of their
way to do it. This is easily done, with the number of men in the jungles and
their rapidly changing character.

The brutality of the railroad police can easily be regarded as fact after
meeting some of them. To a certain extent they cannot handle the tramps
with gloves, but the reaction of the tramp shows that they would cooperate
if they were asked to do so, rather than be bellowed and cursed at. The
tramps in Barstow were careful not to get their fires near the bridge,
knowing that the railroad had trouble with this. The dicks blustered and
bellowed about this, but the bums really did not need to be told to be
careful -- they realized, if there was a fire, that they would be the ones
to suffer in being kept off the trains. They show definitely a willingness
to cooperate, and while the higher authorities would treat them more friendly,
those they actually come into contact with go out of their way to make it
tough and disagreeable for the transient. Again it seems that there never
is a word of encouragement for the bum, the treatment at the Sally especially
included. This only widens the distance between the two sides of the tracks
and detracts from a man's ability to cooperate when he is ultimately
given a chance.

Etc.
* * * * * * * * * * * * * * * * *

# Tex-KT / Research Dept.

## *Meet the Historical Graffiti Society*

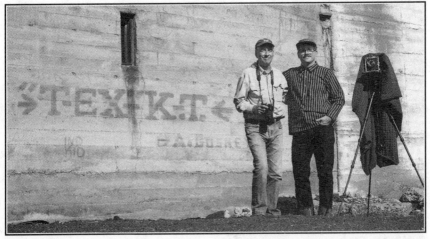

Researchers Mike and Charles Wray, in the field.

"I always put up my signs in the moonlight... I eat, sleep and read in the daytime and at night I put up my signs or travel. I stay mostly along the railway tracks. It is like home to be near the ties." -Tex KT, The Billings Gazette, 1931

This month the Research Dept. is focusing on the extraordinary work being done by the father-and-son team of Mike and Charles Wray, previously based out of Salt Lake City. Among their various projects in the anthropological field of mark-making is a comprehensive study and cataloging of the work of Tex King of Tramps. At this point they must be considered the preeminent authority on this important, but shadowy hobo.

Beginning in 2009, the Wrays undertook an exploration of ghost towns and abandoned structures in Washington State. By 2011, they were encountering and documenting decades-old graffiti in abandoned mining towns across the western states, and by 2013, the pursuit of historic American hobo graffiti had become their primary thrust. In 2018, the pair established the non-profit Historic Graffiti Society, which "preserves and records markings of consequence, with an emphasis on the Hobo era."

In the opinion of this magazine, there is no hobo graffiti of greater consequence and mystery than that of Tex King of Tramps. Anyone who has traveled hard in the West has, at some point, rolled out for the night under a bridge, or beside a shack, emblazoned with Tex's iconic, block-lettered declarations of name, date, and direction of travel. It's still possible to find a legible TKT mark

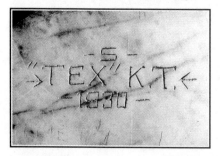

that is 80 or 90 years old.

It should be noted that the Wrays are dedicated to producing their work on analog film stock, often using large format view cameras.

Pioneering research conducted by the society has uncovered numerous newspaper accounts of Tex KT, but there remain many more unknowns than knowns. Charles writes, "Based on our travels and finds, there must be at least a few hundred [Tex

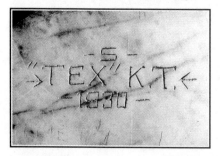

KT graffiti] still in existence. If newspapers are to be believed, there were tens of thousands done over the years.

"Tex was born around 1900 and began his life of wandering around age 14. His marks range from the 1910s into the 1960s. Here the marks seemingly fall off, but there are a few marks suggesting he may have continued into the 1970s or may have briefly picked up marking again."

Found in the Tex KT file in the Mostly True archive is a scrap of paper that says only:

"TEX KT YEARS = 1929-1973" but unfortunately we have no clue as to the source or the veracity of the note. *Always be a lone wolf.*
*Keep out of sight.*
*Always talk nice—say,*
*yes, sir and no, sir.*
*Share money and food with*
*the boys of your class.*
*Mind your own business—*
*travel alone.*
*Look out for your health.    —Tex KT*

Next month in the Research Dept.: Portfio, Mexico's wildest tramp artist, and the documentary that attempts to capture the legend.

(To those who are fortunate to encounter one of Tex KT's works out in the wilds, please respect these priceless artifacts—no side busting, for gosh sakes! —Editor)

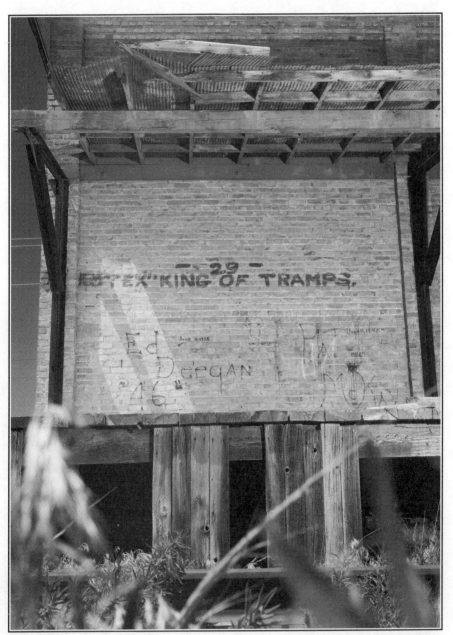

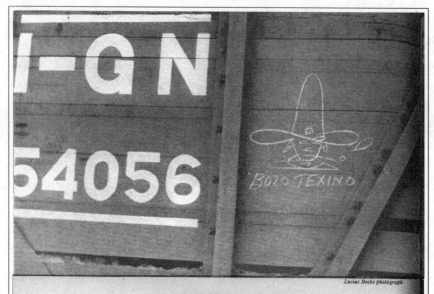

*Lucius Beebe photograph*

### THE WHISTLER OF THE BOXCARS

Boxcar art is largely indigenous to hobos, drifters, and migratory workers who establish a brief esthetic immortality with chalk writing and ideographs. Best known and most often imitated, however, is the hallmark and *fecit* of Bozo Texino, who in real life is J. H. McKinley, a Missouri Pacific engineman from San Antonio, Texas. For years he has been drawing, with an altogether characteristic flourish on the side of boxcars, a cowboy profile with a wide hat, sometimes with and sometimes without a long churchwarden pipe. Authorities on such matters can distinguish an authentic Bozo Texino from a spurious one as easily as a connoisseur can recognize a veritable Whistler butterfly. This specimen, probably no fabrication, but the work of the master himself, was detected on an International Great Northern high car rolling through the yards of the Santa Fe at San Bernardino, California.

From Lucius Beebe's *Trains in Transition, 1941*

# Caught the Westbound

*Lucius Beebe, Newspaper Columnist,*
*Author and Bon Vivant, Dies at 63*

SAN MATEO, Calif., Feb. 4 (AP)—Lucius Beebe, the former New York newspaper columnist, author and bon vivant, died of a heart attack today after retiring in his home at Hillsborough near here. He was 63 years old.

Charles Clegg, Mr. Beebe's associate and collaborator, said that the latter had taken a shower and gone to bed, but began to make strange sounds that attracted his attention. Mr. Beebe was taken to Mills Memorial Hospital, where he was pronounced dead on arrival.

Mr. Beebe left New York and went west in 1950. He and Mr. Clegg bought Mark Twain's old paper, The Territorial Enterprise of Virginia City, Nev., and published it until 1960.

### Chronicled the '500'

Lucius Morris Beebe, an ornate gentleman, drank deeply of the pleasures of the world, and he loved its velvet comforts. His high style in dress, manners and letters made him a New York boulevardier in a mold of his own creation.

For years his Saturday morning column in The Herald Tribune, "This New York," conveyed an astonishing amount of inconsequential but richly detailed reporting about what might be called Mr. Beebe's "500"—that select set of gay and stylish people who populated such "plush puddles" as the Colony, 21, the French Casino, the Cafe St. Denis and others, and who met Mr. Beebe's highly selective approval.

His jottings made him the social historian of cafe society here. Mr. Beebe's knowing trivia was styled in prose that wavered continually between a deft sophistication and bloated wordiness that would not stoop to a familiar word if an obscure one could be found.

His columns were of such words and phases as "calamitous potations," "comestibles," "vaguely anonymous spaniels," "the purlieus of magnificence," "the vestiaire" and "a phalanx of trowels."

Mr. Beebe wrote his own obituary for The Herald Tribune and kept it up to date. It appears in this morning's editions under the title "His Own Life in His Own Words."

In relatively sedate prose, unlike his usual lively style, Mr. Beebe wrote in the third person that "it was a point

©Mark Gerson

## Mr. Beebe in a recent photo

of pride that he had never filed a story from outside continental America. His distate for foreigners was pronounced."

A typical Beebe column would report that "Ona Munson's drawing-room is quite littered with pianos" or that someone named Stanley Sackett paid $7.50 a pair for French lisle socks.

When Virginia Falkner had a cab driver who "emitted a dreadful tale of autobiographic woe, including sick wife, starving kiddies, aged dependents and threatening bailiffs," he reported she gave him a tip of "$25 worth of truffled paté de foie gras in a handsome Strasbourg crock."

Mr. Beebe's absorption with the trifling pleasure of society on the recreational front north of Times Square vexed some readers. His column was dropped in 1944, but he continued writing for the editorial and drama pages. His own view was that "nothing matters but the gallant gesture" and that "the trivia of life may be the solution for all the ills of a fretful and feverish world."

### Devotee of the Grape

Mr. Beebe, a repentant poet who became a syndicated newspaper columnist, was also an author, editor, publisher and an authoritative railroad enthusiast. He wrote almost 20 books, many about trains. He was a gourmet and a winebibber, and

a most inventive practical joker.

Wedded only to elegance, Mr. Beebe rolled around the country for some years in a private railway car, the Virginia City, with a gold and crystal chandeliered drawing room, a fireplace, brocade tapestries, all in Venetian Renaissance style. He was one of the last men in the country to cultivate such magnificence.

Sorting fact from fanciful elaboration in the Beebe legend was deemed exacting work because, since he was capable of practically anything, no story can be dismissed summarily on the mere ground of improbability.

### Hired by Stanley Walker

Mr. Beebe was 27 years old when he went to work for The Tribune in 1929. He presented himself before Stanley Walker, the city editor, who hired him for $35 a week, though it was later recorded that Mr. Walker had "never seen a reporter of such baroque design."

The young newsman once covered a fire while wearing a morning coat and went typically in a top hat and opera cape to night assignments. For two years he covered the ordinary run of news with erratic consequence, leading Wolcott Gibbs to write in The New Yorker that Mr. Beebe "was a tower of Boston erudition and his social philosophy would have amused Marie-Antoinette, and yet he was being asked to wear out his life in vulgar trivialities."

He was then sent to the drama desk, where his tendency toward broad license seemed a bit more fitting. He interviewed actors and anathematized bad plays and motion pictures, having little opportunity to do otherwise, since as an understudy critic he was rarely sent to anything good.

He was fully up to the task. Mr. Beebe, who had cultivated the ability to be haughty in college, handed down dicta with sweeping dismissal. He described radio as a medium "debased beyond the dreams of vulgarity." He saw Hollywood as "full of preposterous mountebanks and bores who live in the most witless and spurious manner ever devised."

Lucius Beebe was born at Wakefield, Mass., on Dec. 9, 1902, and he eventually grew to 6 feet, 4 inches tall and 180 pounds, excellent proportions for a man of custom attire who was never indifferent to

his effect. His father, Junius Beebe, was president of the Brockton, (Mass.,) Gas Company and was a Boston bank director.

Lucius spent his early years on the Beebe farm, a 140-acre preserve suitably removed from the center of Wakefield as to enhance the family's reputation there as aristocrats, and the young man grew up with no inconsequential image of himself.

As a prank, he blew up vacant outhouses as a lad with sticks of purloined dynamite, and the child was father of the man. He was sent through the North Ward Public School in Wakefield for the sake of democratization and then on to St. Mark's for a little toning up, but the school despised his skill at dynamiting things and sent him home.

At Berkshire School in Sheffield, Mass., he discovered drinking. The school also found him a bit much and returned him to parental care. Somehow he survived the Roxbury School in Cheshire, Conn., where many recalcitrant scholars were sent for confining discipline, and he went on to Yale.

He flailed a gold-headed cane with superb aplomb, kept a fully stocked Prohibition bar in his dormitory room, and wore plus fours, cutaways and "grey orchidaceous trousers," as The Yale Daily News called them. This engendered some irritation among conformists. It was said that Prof. Chauncey B. Tinker, spotting young Beebe at a distance in pantaloonlike white linen knickers, complained that Yale was overrun with women and said, "Here come two of them right now."

Always a prolific writer, Mr. Beebe wrote for the Yale Literary Magazine and he published "Fallen Stars," a book of verse, as a freshman.

What might be called the "Beebe versus Tweedy" encounter brought the student to a terminal celebrity at Yale. The university had a distinguished Divinity School, and Mr. Beebe apparently found mere proximity to it galling, especially when 99 out of 100 students there endorsed the strictest enforcement of Prohibition.

The ratio outraged young Lucius, who wrote a warmly denunciatory tirade for the school paper. Prof. Henry Hallam Tweedy of the Divinity School replied with such stern rebuke that the student was moved to write an apology.

But two weeks later he came out of sackcloth. At the Hyperion Theater one night, a bearded figure rose in a box. "I am Professor Tweedy of Yale

And Mr. Beebe as once seen by the cartoonist Rea Irvin

Divinity School!" the youth shouted, raising his arm and sending an empty bottle clonking onto the stage.

The Administration decided that Beebe and Yale were inherently incompatible.

Moving on to Harvard, the pranks of his New Haven days soon paled beside the grand gestures of his Cambridge period, which included an arrest for selling counterfeit tickets to a ball and a chartered airplane flight for the purpose of dropping tissue streamers on a pleasure fleet at New London.

He was graduated from Harvard in 1927, but we went on to graduate school to study poetry, having published a book about François Villon and another book of poetry, "Croydon and Other Poems."

A thesis on the poetry of Edwin Arlington Robinson was a serious venture punctuated by one terrible lark, in which Mr. Beebe borrowed some blank verse that the poet had suppressed as unworthy, and published it in a limited special edition, which he circulated among libraries in the United States and England and literary persons.

When young Beebe beat up the man who reported this bootleg enterprise to Mr. Robinson, Harvard asked him to leave, but he secured the poet's forgiveness and returned to earn a master's degree.

Four years later, The Tribune syndicate sold a weekly column by Mr. Beebe called "So This is New York!" to about eight out-of-town papers, but did not itself use it until 1934. under an altered name. The column, together with the author's flamboyance, won him a reputation, though only about a dozen papers ever ran it at one time.

He was with the newspaper from 1929 to 1950, and he was nearly always the first man in the office in the morning. "He often wrote his stuff after a night on the town, sitting at his typewriter at 5 or 6 A.M. in a tuxedo or white tie and tails," a former copy editor said. "He wrote in serpentine sentences, tossing in such rococo words as 'ormolo.'"

For 10 years, from 1950 to 1960, he was the publisher of The Territorial Enterprise, a Nevada weekly, which he gave a Wild West flavor, and Charles Clegg was the editor.

In his own obituary notice, Mr. Beebe wrote that The Enterprise's "fame derived largely from its editorial page, which derided all manifestations of progress and modernity and espoused the cause of 'benevolent backwardness.'" In 1960, he began a column in The San Francisco Chronicle, which continued until his death.

He and Mr. Clegg joined as a writer and photographer team to produce a series of handsomely illustrated text-and-picture books on the West and railroading.

Mr. Beebe's books included: Boston and the Boston Legend" (1935); "High Iron: A Book of Trains" (1938) "Dreadful California" (1947); "The U.S. West: The Saga of Wells Fargo" (1949) and "Legends of the Comstock Lode" (1950).

He was a bachelor and left no immediate survivors.

*Continued from page 43*

part: old heads, and people who never planned to retire in the craft. This was the climate that fueled years of not having a National Union contract. Abuses from executives and managers have always produced a plaid Grapes of Wrath type figure that pairs well with overalls and heartache. The implementation of Precision Scheduled Railroading (PSR) at the beginning of 2022 saw this kind of employee resign en masse. The small town blue collar individuality of a railroad worker knew how the local mill liked their cars spotted, and cared when the regular operator was out sick or had a sick kid. In a 15-month period, over 2,500 TY&E (blue collar) employees were lost from a certain class 1 railway carrier in the Midwest that will go unnamed here. The exodus due to a combination of resignations, dismissals, or they failed to return from their extended furloughed status. I'm haunted by the faces of coworkers across the 7 states I've worked who have quit that otherwise wouldn't. People who you have trusted your life to... the psychological toll of watching them quit each week by the dozens. I don't speak for everyone, but I did have ears. Personally, I favored the work stoppage in 2022, not because of the lack of contract or raise, I wanted the perpetrators who implemented Precision Scheduled Railroading to feel the stress. The strike drama was multifaceted, but remained divided. I remember my own union representative, on a figurative soap box, (on a daylight shift at that!) anonymously criticizing anyone within ear shot how dumb they must be to vote in favor of a strike. "This is as good as you're going to get." was echoed by our own,

now former, National Union President. The Conductors United Transportation Union did get the votes to strike. Yard workers overwhelmingly voted over road conductors in favor of strike. Well, we all know how it ended. Congress introduced a second bill alongside the original that decided if we got to strike. I saw the second as a distraction. When both failed, every worker felt let down in the bipartisan agreement. Deep down at our core, it brought to the surface a seldom seen common interest. We listened to it all on the radio in the depot like a baseball game. My loyalty will always be to the blue collar workers. We are all we have out there. The buttons to our jackets. As far as employee morale goes, railroading in 2022 is like showing up for a diner reservation on the Titanic... after they struck the iceberg.

By Michael R. Green,
Conductor

*"There's the trouble!"*

# Catches

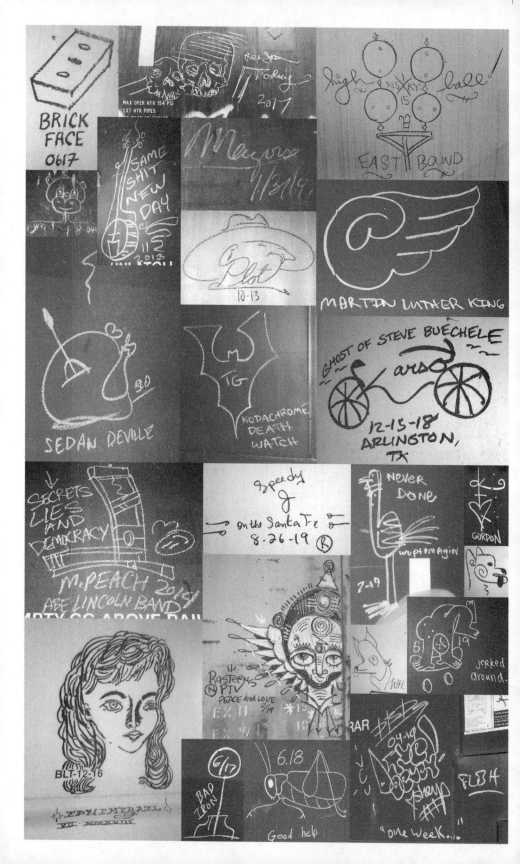

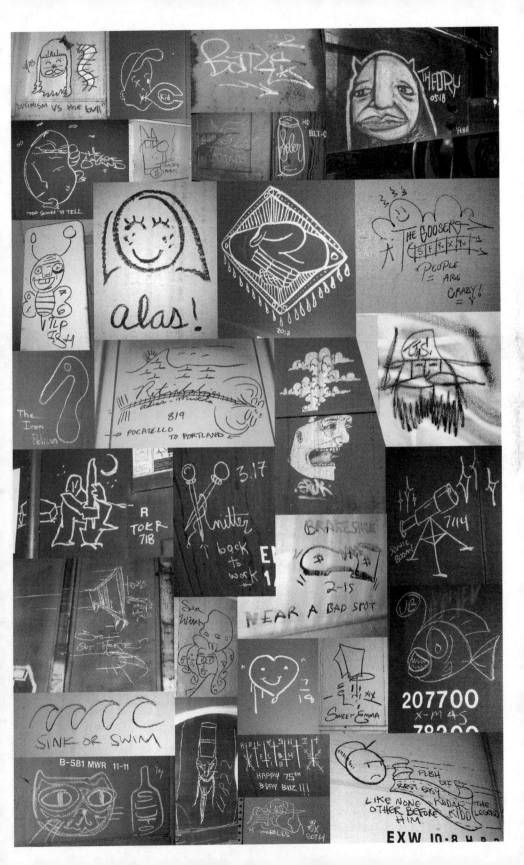

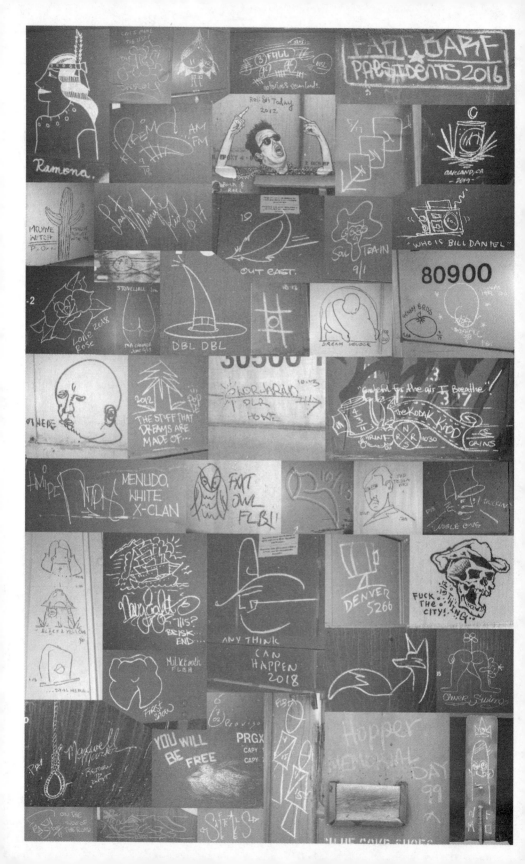

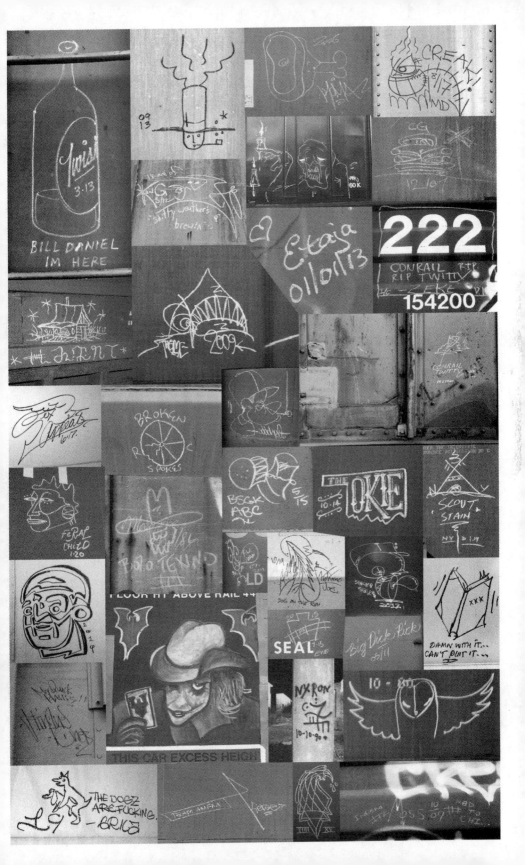

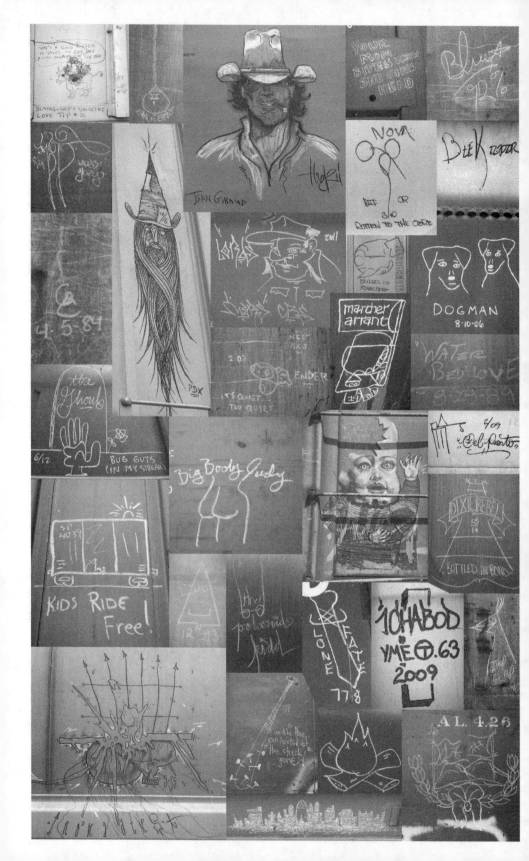

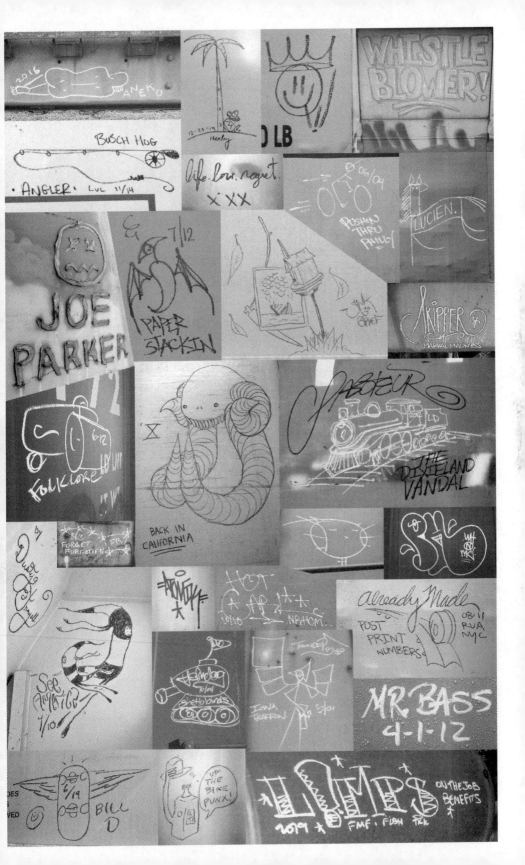

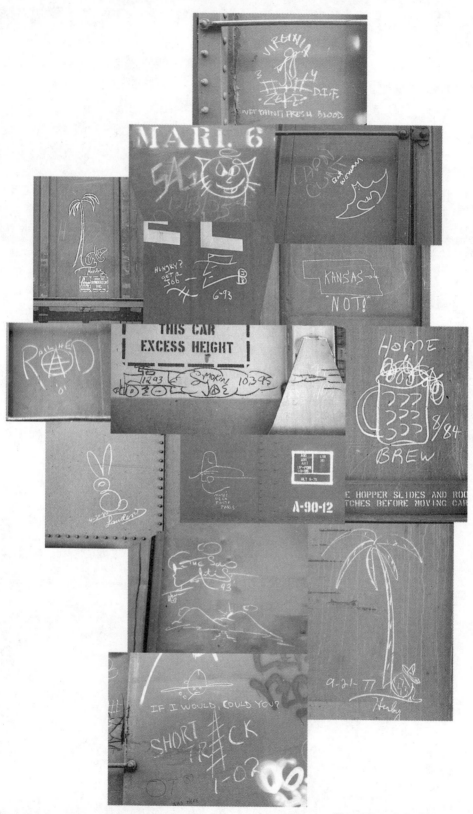

*Photos this page by Daniel Leen*

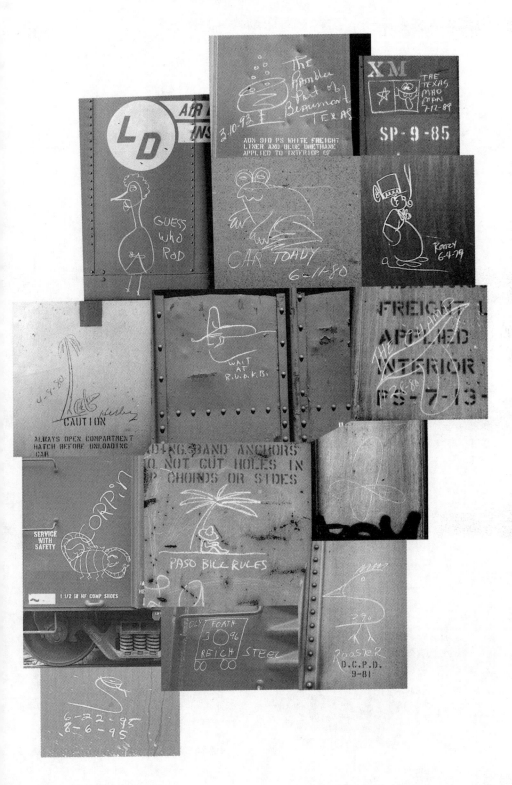

*Photos this page by Daniel Leen*

MICHAEL BRODIE

His new book, *Failing,* will be published
by Twin Palms this year.

Record store, Austin, Texas

# Better "Hay" for the *New Iron Horse!*

**D**iesels have replaced the romantic but outdated steam locomotive on most of America's railroads. Reason? Diesels are more economical to run and maintain.

But, the once-held theory that diesels will "burn almost anything" is a costly fallacy. Sinclair—a big supplier of diesel fuels to railroads —knows that, and is constantly concerned with the quality of the "hay" for the new iron horse.

Consequently, Sinclair is a leader in research to produce diesel fuels with better starting, ignition and combustion qualities. Sinclair has pioneered in the development of diesel starting fluids, and by its discovery of RD-119®, the amazing new rust inhibitor, produced the world's first anti-rust diesel fuel.

Through this and other research and development work, Sinclair has made continuous progress in the production of diesel fuels with higher performance standards. It's another in the list of reasons why Sinclair is . . . a great name in oil.

**SINCLAIR OIL CORPORATION**

**600 FIFTH AVENUE**

**NEW YORK 20, N.Y.**

## SINCLAIR
*A Great Name in Oil*

# Gone

*Our Continuing Series On Disappeared Railroad Infrastructure*

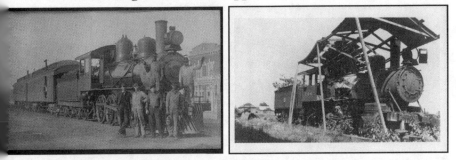

*Left: T&H's pride and joy, engine No. 6 poses with her crew during the happy times of 1910.*
*Right: Final resting place at Henderson, under what passed for the company's "roundhouse."*

## RIP, T&H
### Reported by Murry Hammond *

**Down East Texas way,** we memorialize the passing of the Timpson & Hender-
son Railway, a little branch job that tapped off the Houston East & West Tex-
as (aka "Hell Either Way Taken.") The HE&WT was made famous in the Tex
Ritter tune, "Tenaha, Timpson, Bobo and Blair," a crapshooters' phrase turned
popular hit song. The T&H began life in 1909 as a rough log tram put in by a
kindly old German orphan by the name of Wolfgang Ragley. He had the idea to
extend his logger 34 miles to Henderson, throwing up depots along the way at
Ragley, Pine Hill and Longbranch.

The line got into money trouble from the start. Its main customer, the lumber
mill at Ragley, burned in 1910. The company limped along for a few more years,
but by the Great War, brass could no longer afford to run the big engine no. 6.
To keep the mail moving, a highway truck was fitted with flanged wheels and
operated every day but Sunday. But the savings afforded by the truck was not
enough to pay the bills, and train service stopped.

Before the reaper could lower the hatchet, the line had one last whimper. The
story goes that, in the spring of 1924, a sedan-style automobile was fitted with
flanged wheels and painted a festive red color. An ad was placed in the local pa-
pers for residents along the route to "Ride The Shopping Train!" The car made a
few successful runs, until one day the car encountered an angry bull which gored
the radiator and stranded the shoppers. Thus ended the "shopping train", and
with it, the Timpson & Henderson.

Abandonment was soon approved and all iron, including engine No. 6, was
sold to the scrappers. The old coach was given to the master mechanic in lieu
of years of back pay, and the old Ragley mill town became a ghost town. These
days, the only visible part of the line is around the old Ragley mill pond, which
enjoys life as a popular swimming hole, and where stories are still traded about
the old T&H. ▰▰▰⬥

*Bass player for Old 97's

## Prefatory Notes from
# The Milk & Honey Route
## (1930)

### by Dean Stiff

Whenever the ink-slinger in Smokey Bill's gandy dancing camp would take up his pen to discount a man's time-check, the hobos used to say that at figuring he mowed a mighty swath. It is not so easy to mow a mighty swath in the field of letters, but when one has something to say, even an amateur pen need not falter in the telling.

I have a good deal to say about that much maligned subject, the hobo, and about Hobohemia, the habitat of hobos. I have advice to offer the young man ambitious to become a hobo; it is an important calling and not to be entered upon too lightly. True, many volumes have already appeared on this subject. I have read most of them. I can approve of none. Thus, you see, however inexperienced my pen, I am starting with the true spirit of the expert. Here and there in these many hobo books is a grain of truth. The rest is chaff. Unfortunately, by employing artful pen and bombastic ego, one self-styled "authority" after another has been able to make the chaff seem like wheat. In every case they have only dabbled in false colors, and distorted the picture. The true picture of the hobo and his life in that best of possible worlds, Hobohemia, remains to be drawn, while no

one has even attempted to compile directions for the guidance of the neophyte.

This failure to tell the truth is not altogether to be explained by a lack of respect for veracity, however much that may be in evidence. The hobo, for all his simplicity, is still a phantom man, and Hobohemia still remains too obscure to be interpreted validly by any casual or occasional visitor. No fictionist can explore the hobo's province by riding across it as Stevenson explored Europe on a donkey. Bumping over the terrain, like a stone rolling down a hill, may be as good a way as any to go slumming or sightseeing; but Hobohemia does not yield to such inspection, except to distort the visions and shame the findings of these transient reporters.

Assume that these reporters, these researchers, novelists, and spectacular artists are sincere—and that is being charitable—sincerity is not enough. The hobo world yields its truth as grudgingly as a distant planet. The uninitiated seldom see what is visible, and rarely interpret in its true light what is revealed to their senses. The true reporter must be of the blood, and they of the blood are few. He knows the truth because he lives it. He doesn't mix in the social sea of Hobohemia like a man floating on a life preserver; he becomes identified with the spirit of the wandering man, the Homer of ancient times, the Meistersinger of the Dark Ages, the roadside magic venders and vagrant story-tellers of every century and every clime. He who lives the truth needs no other muse to guide his pen.

Hobohemia is a realm apart from the world, yet it interpenetrates every other realm of human society. It is a habitat not made by the hobo, nor is his existence within it subject to his own manipulation. Control on his part is not needed, for this is God's providence, the only remaining spot of the original Garden of Eden. Rarely does the hobo himself comprehend this Garden, though in it he is comprehended. His life and his living is rationed out to him for the day and by the day, as it is to all the other favored creatures of the earth. It would be folly to ask the lilies of the field how or why they are so arrayed in loveliness, or to demand the robins explain the plan of their existence. Thus the hobo can and does live the life of the consummate artist without being aware of it.

Knowing these things as I do, and reading the trash of erstwhile dabblers and puddlers in hobo lore, I cannot resist the opportunity of issuing this broadside. This is not meant to be a diatribe against anyone in particular. Certainly I have no desire to disturb any of the hobo Boswells now fattening on the wealth showered upon them for their alleged memoirs of hobo experience. Their days are numbered. Much less would I assail certain estimable members of universities and learned societies, however much they have been honored for their so-called researches in Hobohemia. They have scarcely scratched the surface, and whatever truth they may have unearthed has

by its very thinness been perverted. This book is not only my protest against all such puny peripheral effort, but my attempt to present, out of the fullness of experience, the true picture. This is meant to be a guide for the curious, and so valid in its content that beside it all the cheap patter of mountebanks and eavesdroppers will pale like a candle before the sun.

## CALL YOUR MOTHER

BETHANY, aka, Roadkill." Please come home. We love you. Mom, Dad, Billie, and Bobby. We are sorry.

Dear Betsey Epstein, "Peachie" or "Elaine": We once said we were all responsible to each other. You have responsibility to call your upset mother, so she will know you are alive. If you telephone, I will tell missing persons to stop looking for you. Some day you will grow up to be a fine woman. I hope. --Dad

Does anyone know Pete, "Winebag Pete", "Pete Patches", etc? If so, please tell Pete his girlfriend wants to buy him a bus ticket home, and she is sorry for getting him mixed up with trains and bums and marking on stuff. It's not too late to come back.

Samara "Matchstick"-- If you or "Dumpy" are reading this, please call us or Art at work 858-5519 or 243-3700 ext.117 after 6. We miss you very much. Nothing will upset us if we could only hear from you. Butcher, your sister told me what happened. Man, I'm sorry I won't see you again.

EL PASO FRANK and PLANO KID, you both can still avoid jail if you appear in Somerville at the right time. Phone the P.S. or Mr. C., or have someone phone for you if you are afraid.

MAYLOCK, please call your mother and reverse the charges. Call person to person and keep trying until you get me at home. I want to give financial help. When you call use the name MAYLOCK

Claudia and Jamie, the Greenwich Police Department, your mother and I, and Mrs. Frankweiler are all frantically looking for you. What could make you run away like this? Where could you possibly be?

## HELP WANTED

### HIRING BAGGERS
The Plastic Bag Store. Apply in-person.

## FILMMAKERS

Need a title for your new railroad adventure movie? Send SASE for our new list, Last of the Great American Hobo Movie Titles. Boxcar Pictures, LLC, 2425 Market St., Galveston, Tex.

Bindle stiff

Texas Bob  Ozark Mike  Moon rider  Dirty Dan  Snake  Trainwreck
Little Swede  Cigar Willie  Digger  Scorpion  Michigan Bil

*From Oklahoma Slim*

# Thanks

At the top of the thanks heap are Joe Biel and Elly Blue of Microcosm Publishing for giving me the opportunity to make this book, and for their patience with me and the chaotic process it took to finally finish this dang thing. I could have kept adding to it for another four years. As Barry says, "One more thing..."

Great appreciation and respect is due the designers who shared their labor and graphic genius with this project over the many years. The original team in 2008 responsible for the *Mostly True* style was Gary Fogelson, Phil Lubliner and Rich McIsaac in Brooklyn. The 2012 second edition was built by Rich McIsaac in San Francisco. This third edition is the result of heroic design-build work by Jordan Swartz in Austin and Vlad Nahitchevansky in Kingston, NY. Michael Torchia in San Francisco gave a last-minute design push at the finale.

Contributing writers, photographers, researchers, artists, and supporters include: J. Alone, Craig Baldwin, Eden Batki, buZ blurr, Colt Bowden, Bruce Brakeshoe, Russell Butler, Emmy Butler, Owen Clayton, Kyle Cochran, Colossus of Roads, Aaron Cometbus, Tim Conlon, Beau Patrick Coulon, Walt Curtis, Mari Cutpiles, Anson Cyr, Lee Daniel, Ken Davis, Ted Dement, Dirt Bike Magazine, Brice Douglas, Andy Dreamingwolf, Charlie Duckworth, Spencer Eakin, John Easley, David Eberhardt, El Paso Kid, Marisa Evans, Tav Falco, Ted Faves, Max Fenton, Jack Flash, Gary Floyd, Lydia Fong, Sam Friedman, Aaron Frisby, Jason Fulford, Roger Gastman, Mica Gibson, Vaughn Gibson, John Gordon, Michael Green, Green Thumb, Archie Green, Brad Hales, Michael Hall, Nathan Hall, Murray Hammond, Hans Hanson, Toby Hardman, John Held Jr., Inner Sanctum Records, Margaret Kilgallen, Stuart Kogod, Max Kuhn, Hobo Lee, Daniel Leen, Sam Liebert, Conway Link, Michelle Lockwood, Scott Mac Leod, Mainline Mac, Steve Mason, Reggie Mcleod, Miab, Mikey 907, Shawnee Miller, Mojave Witch, Mudflap, David Nelson, North Bank Fred, O. Winston Link Museum, Oklahoma Slim, Old Broads, Other, Overcoat Slim, Justin Parr, Christos Pathiakis, David Pedroni, Larry Penn, Scot Phillips, Susan Phillips, The Bitter Stranger, The Polaroid Kid, The Rambler, Relish Today, Rankin Renwick, Brette Richmond, Duke Riley, Roadhog USA, Paul Rogers, Mack Royal, Eric Saks, Andrew Shirley, Natasha Shirley, Sluto, Smokin Joe, Shlomit Strutti, Choo Choo Tane, Naoko Tani, Tex Goth, Texas Connection, Kurt Tors, Mick Trackside, Sharon Trahan, Philip Trussell, Matt Tucker, Heidi Tullman, Nick Turkette, Scott Van Horn, Webb Gallery, Brad Wescott, West Coast Blackie, Ralph White, Amanda Wong, Charles Wray, Mike Wray, and Yors. Thank you all so much. And, thanks to anyone I've missed here, and to everyone out there who has contributed to the culture of *hobo graffiti*.

Dedicated to the memory of Blake Donner and his zine, *The Fifth Goal*.